THE CARE OF PHOTOGRAPHS

SIEGFRIED REMPEL

The Care of Photographs

LYONS & BURFORD, PUBLISHERS

Printed in the United States of America.

10 9 8 7 6 5 4

Library of Congress Cataloging-in-Publication Data

Rempel, Siegfried.
 The care of photographs / Siegfried Rempel.
 p. cm.
 Includes index.
 ISBN 0–941130–48–7 (pbk.) : $16.95
 1. Photographs—Conservation and restoration. I. Title.
TR465.R46 1987
770'.28'6—dc19 87–33938
 CIP

To
Caleb John, who released several of my evenings for me;
Don, who showed me alternatives;
Decherd, who taught me patience;
David, who provided the idea;
and to
Cliff and Klaus, who motivated it all.

Contents

Introduction 1

1. Photographic Processes 3

2. Examining and Handling Photographs 12

3. Deterioration of Photographs 45

4. Cleaning and Stabilizing Photographs 78

5. Environments for Photographic Materials 105

6. Housing Photographs 125

7. Conservation Services 162

Suppliers 167

Bibliography 171

Index 179

Acknowledgments

I would like to thank Murray Frost, Senior Environmental Conservator, Museums Assistance Programme, National Museums of Canada for his many comments and suggestions, and Johanne Perron, Conservator, Canadian Center for Architecture, for her assistance in preparing this book.

Introduction

The demand for information concerning the care and handling of historic photographs has increased dramatically over the last decade. But the number of books and articles dealing with basic care and preservation of these materials, is only now beginning to meet these needs. This book hopes to resolve some, if not most, of the questions you might have about preserving photographs in your custody.

Preservation, for the purposes of this text, will deal with the collective welfare of photographs. The treatments tend to be preventative, and generally apply and include things such as the environmental conditions the photographs exist in, the preparation of materials to minimize damage as well as chemical and physical changes during use, and particular measures you can take to insure the longevity of the photographic image while using and enjoying it. This is also referred to as preventative conservation.

Conservation is a service activity provided by trained professionals to a client, institution, or collection and deals with specific problems associated with a particular image or group of similar images. The treatments tend to be dedicated, sophisticated, and often unique, since any given problem may be particular to that artifact.

Restoration, on the other hand, is generally not used in describing the treatments applied by a conservator. The restoration of an image can include techniques that in themselves compromise the photograph either ethically or chemically. The embellishment of the photographic image to improve its appearance is often at odds with its long-term stability, and as such represents a non-conservation treatment. Restoration may not provide the level of responsibility you would like for your collection.

This book includes many of the concepts employed by professionals in pho-

tographic preservation. It includes a chapter on the most common photographic processes, with emphasis on those of the nineteenth-century. Chapters on handling and examination—as well as deterioration, environment, and appropriate housing for photographs—are also included. The last chapter attempts to provide some guidelines for dealing with conservators.

The goal of this book is to provide information appropriate to the preservation of photographic materials, so that you might exercise the options available to you for the protection and safekeeping of your photographs. The field is rapidly evolving and our understanding of different problems is dynamic. In this text are some of the concepts you should be aware of as you work toward comprehensive preservation of your photographic collection.

1

Photographic Processes

Materials that collectors, librarians, archivists, and curators will have in their care include all forms of photographs, but the materials most popular, and certainly in greatest demand by patrons and staff, will be positive images, usually on a paper support.

Positive photographic materials are generally viewed by reflected light, and the support is usually paper, glass, metal, or, in some cases, plastic. Glass and plastic materials may also be viewed by transmitted light. Positive images are popular primarily because the image is immediately recognizable. The negative image, being a reversal of the photographic values, is not easily read by nonspecialists.

The photograph is a composite of several different layers, each of which may react in a different way to the immediate environment and in some cases to each other, and generally includes a support, a binder, and an image-forming component. Additional components may be present that have been added to alter the aesthetics of the photograph, to improve the adhesion of the various layers to one another, or to improve the stability of the photograph itself.

This section is not designed to provide an identification scheme for photographs but rather a reference to the more popular photographic processes, with a brief history of each and some notes on the methods of fabrication. The processes fall into three groups, based on the major image-sensitizing and image-forming components: silver, iron, and chromium.

SILVER PROCESSES

The first set of processes we will examine are the silver sensitizers producing a final image of silver. Silver has been the primary medium used to form the image

3

of the fabricated photographic print throughout the history of photography. It was the first commercially-based process and is in fact still the basis on which contemporary photographic systems are based.

The use of silver in a light-sensitive system has its origins as early as 1727, when Heinrich Schulze accidently determined that a silver nitrate solution was light sensitive. The process of inventing a practical system of photography required several other developments, including Thomas Wedgwood's use of silver nitrate or silver chloride to produce silhouettes on paper and photographic copies of drawings (on glass), in 1802. In 1814 Sir Humphry Davy discovered the light sensitivity of silver iodide, a compound that would become the working light-sensitive compound employed by Niepce, Daguerre, and Fox Talbot in the first successful photographic systems.

The First Silver Processes

The first successful photographic processes were silver-based images and involved a contest between Daguerre and Fox Talbot. Louis Jacques Mandé Daguerre eventually resolved a photographic system using silver iodide as the light-sensitive compound in which he developed the image with mercury vapors and fixed it with a bath of sodium thiosulfate. The daguerreotype process was sold to the French government on July 30, 1839, and a British patent was granted on August 14, 1839. The daguerreotype was in popular use by the end of 1839.

William Henry Fox Talbot invented photography with negatives and positives that also utilized a silver light-sensitive system. The process was called the calotype by Fox Talbot but is also called the Talbotype. The evolution of this process paralleled the work by Daguerre and was also based on work done by Schulze and Wedgwood. The experiments involved both silver nitrate and silver chloride coated on a paper base. Talbot's work began in 1834 and by 1839 he had reported his process to the Royal Society. The calotype at this time made use of a silver chloride light-sensitive salt in an environment of excess silver nitrate and fixation was achieved with sodium thiosulfate. The calotype did not compete with the daguerreotype. Although it was invented just prior to the daguerreotype, it does not come into consideration until after the February 1841 patent was granted to Talbot for his calotype process.

It is interesting that of these first two photographic systems the calotype, which produced an in-camera original negative from which a positive print was made, utilizes the same basic fabrication steps as the contemporary silver system.

The Early Print-Out Processes (POP)
The evolution of the silver-based processes centered on the calotype process rather than the daguerreotype. The reasons for this can be seen by tracing the evolution of the calotype. The chemical development of a latent image, providing a negative from which multiple positive prints could be made, is the most significant factor. The daguerreotype was a unique, in-camera original.

The one feature of the daguerreotype that the calotype could not emulate was the fine detail and high resolution possible with the process. The calotype image is clouded, first by the paper fibers of the negative, and second by the fact that the light-sensitive, image-forming salts penetrate into the paper support and appear as a matt image. This flaw was resolved to some degree with the invention of glass negatives by Niepce de Saint-Victor in 1847.

Photographers attempted to reduce this penetration of the paper by silver salts by sizing the paper's surface, reducing penetration and thus keeping the image on the surface or at least in the uppermost portions of the paper. The color difference of calotype images was initially due to the difference between gelatin-sized papers, which gave a warmer color to the image, and starch-sized papers that gave a cooler image color.

Among the various materials used for sizing was albumen. The use of albumen for photographic negatives began with Niepce de Saint-Victor's glass negatives, which utilized a substratum of albumen as the binder for the silver image. This layer of albumen mixed with potassium iodide was dipped into a silver-nitrate sensitizing bath and remained on the plate for exposure and processing by development in gallic acid, later in pyrogallic acid. The term Niepceotypes, or albumen on glass, was used to describe this process, which give structureless, transparent negatives.

The application of the albumen surface size for positive silver prints probably began in a similar way. A list of sizing agents was provided by Blanquart-Evrard in 1850, and it included albumen. The albumen print process begins with Blanquart-Evrard's preparation in which the albumen is beaten, salted, and the paper is coated by being floated, sensitized, exposed, and processed.

The continuum from the calotype print to the albumen print includes the general description of paper prints as salted silver prints or plain salted prints. The basic calotype positive fabrication process remained unchanged but included the evolution of more and different gold toning bath formulations, in some cases providing double toning, to provide image-color modification and increased permanence.

The Later Print-Out Processes

The albumen process for positive print images and the wet-plate collodion process for making in-camera negatives for printing positives became the functional process pair for most of the nineteenth century.

The albumen process became popular in the early 1850s and manufacturers began to supply photographers with albumenized papers from about 1854, when a German firm began commercial production of salted albumenized paper. The albumen paper began to lose its popularity in the 1880s, but was still available until 1929 when the last manufacturer stopped production. The photographer still sensitized and processed the print, but the albumenizing was already produced in the manufactured product.

The wet collodion process for making negatives on glass supports began with an 1850 publication by Gustave LeGray of a description of collodion in ether being poured onto glass to act as a binder and carry a photographic layer. The first workable application, however, was achieved by Frederick Scott Archer, published in 1851 and known as the wet collodion process. The fine grain of this process and the transparency of the glass support prompted a switch from calotype paper negatives and albumen-on-glass negative processes to the collodion negative process. The positive prints were mostly printed using the albumen paper process and the finished products had a very high resolution.

Manufactured Silver Print-Out Processes

The wet collodion process remained the active, photographer-fabricated negative system, but the paper products shifted from albumen to collodio-chloride and gelatino-chloride. These two processes were fabricated and sensitized by the manufacturer for immediate use by the photographer.

Collodio-chloride emulsion papers were introduced in the 1880s, although collodion emulsion on a paper support had been produced as early as 1861. The term "emulsion" is used here to identify a binder layer in which the light-sensitive silver salts are suspended and which, after development, will still be isolated from the paper support upon which the layer is located.

Gelatino-chloride emulsion papers also made their appearance in the market place in the 1880s. The emulsion binder in this case was gelatin, again with a suspension of silver within the layer and the layer isolated from the paper support. The manufacturers of these products prepared the paper's surface by coating it with a layer of barium sulfate or baryta. The presence of this layer prevents the

interaction of the image-carrying layer and the paper base, and was developed primarily to reduce such interactions.

Develop-Out Print Processes (DOP)

Gelatin Silver Prints
The evolution of silver gelatin emulsions for dry plates paved the way for the marketing of silver gelatin emulsions on paper supports. Experiments in the use of gelatin as a binder can be traced back to Poitevin in 1850. Experimentation continued, and in 1871 Dr. R. L. Maddox sent details to the *British Journal of Photography* that discussed the preparation of a gelatin silver bromide emulsion used as a dry plate in-camera negative. His applications included layers coated on paper.

The first commercial source of the gelatin silver bromide paper was announced in the *British Journal of Photography* in 1874, by Peter Mawdsley as the Liverpool Dry Plate and Photographic Printing Company. The chemical processes continued to be improved and by 1879 there were several factories and manufacturers of silver bromide emulsion products. The wet collodion process was almost entirely displaced by the silver gelatin emulsion dry plates by 1880. The evolution of the process continued rapidly during the 1880s, but the silver print-out papers were still competitive and remained in the market. The silver bromide paper allowed for rapid printing using artificial light and was used for enlargements.

The popularity of matt silver bromide papers was established in 1893–4, and was achieved by mixing starch into the emulsion. These matt papers displaced many of the glossy papers, including the print-out papers in use by commercial and artistic photographers.

Gelatin silver chloride emulsion development papers (also referred to as "gas-light"), were introduced in 1881, and were in production by manufacturers in 1882. The silver chloride paper was much slower than the silver bromide paper but allowed for a wide range of image colors, depending on the development given to the print.

Gelatin silver chloro-bromide development emulsions for prints were described by Josef Maria Eder in 1883. This mixture is more sensitive than silver chloride emulsions alone and produced warmer tones than the silver bromide emulsion papers.

Today these manufactured emulsion papers are represented by the Azo and Velox type of contact speed silver-chloride development papers, as well as Portiga

as a chloro-bromide development paper and the bulk of contemporary papers such as Kodabromide, which are silver bromide development papers.

The gelatin silver print represents the contemporary silver developing-out print process. The process has the coating of baryta applied to the paper support, followed by the gelatin emulsion binder layer. In this case the light-sensitive salts are silver bromide or a mixture resulting in a silver chloro-bromide emulsion. Traditionally this was a paper-base process, but in recent years the industry has introduced a resin-coated paper. In this configuration the paper base is surrounded by a layer of polyethylene onto which the emulsion has been coated.

Silver Positives on Glass and Metal

The collodion wet plate process, when underexposed and developed in a formulation that whitened the exposed areas of the negative, was placed over a black background and produced a positive image. The ambrotype (also called amphitype) was produced during the mid 1850s. The back side of the plate was usually coated with a black varnish, paper or cloth.

The wet collodion process, when applied to a black-lacquered iron plate, produced a positive image. This process was originally called a melainotype, but became known in North America as the ferrotype or tintype. This process was a direct positive. The black-lacquered plates were in use until 1870, when Hedden patented a brown-black lacquer which soon became popular with portrait photographers. The fabrication was similar to the wet collodion process; it continued into the 1930s in North America and is still being used by itinerant photographers in some countries.

Gelatin Positive on Glass

Transparencies on glass were known as lantern slides. The fabrication steps were similar to the negative gelatin emulsion process except for the formulation of the salts used in the emulsion and some of the processing steps.

Plastic supports were also used as a replacement for the heavier glass support and again the silver bromide emulsion coated onto the plastic support could be either negative or positive; the majority being negatives.

Flexible Supports

Pre-Plastics

Attempts to provide a flexible support for the light-sensitive silver salts took place as early as 1856. In 1869 Hyatt Brothers produced negatives on semi-rigid cel-

luloid sheets, and in 1875 Warnerke produced a dry collodion silver bromide film on chalk-coated paper that could then be stripped. Through the 1880s a number of improvements were made and in 1887 Goodwin patented a celluloid roll film support. This patent was not granted to him until 1898, when the courts recognized his claim to the process.

Eastman produced a stripping film that utilized a paper carrier and patented it in 1884. During the patent dispute between Eastman Kodak and Goodwin, Kodak perfected the technique of casting a liquid cellulose nitrate sheet mechanically, but the patent was eventually granted to Goodwin and the Kodak company had to negotiate the rights to the process.

Plastic Supports

CELLULOSE NITRATE

The process of casting a cellulose nitrate sheet was patented by Goodwin. The process involved the dissolution of collodion in solvents which were then cast onto a smooth surface. Once the solvents evaporated, a strip of flexible cellulose nitrate could be coated with a silver gelatin emulsion and stripped to form a roll film. Eastman Kodak produced the first mechanized-drum casting process in 1893, but the film showed extensive curling. Non-curling film was introduced by Kodak in 1903 by coating the back non-emulsion side with a gelatin layer.

CELLULOSE ACETATE AND POLYETHYLENE TERAPHTHALATE

Cellulose diacetate was developed to replace the chemically unstable cellulose nitrate and it was called *safety* film. Its use as a 16mm film base spread after 1922 in the diacetate form. Mixed cellulose esters were introduced in 1931 in an attempt to improve dimensional stability and reduce chemical instability. The early diacetate films had a subbing layer made of cellulose nitrate and often show a separation of the base and emulsion in trough-like channels. The mixed esters were cellulose acetate propionate and cellulose acetate butyrate.

Cellulose triacetate was introduced as a film support in 1948, and between 1948 and 1951 the last cellulose nitrate base films were replaced. The triacetate provided durability and stability required of the motion-picture industry and it is still manufactured today as a film support.

The last plastic support to be introduced was a polyester, polyethylene tere-phthalate, in the 1960s. The polyester plastic had been invented in 1941 but application in the photographic field could not be made until a new, non-solvent splicing technique was devised and the static-electricity generating aspect of the

plastic was solved. The product is now used throughout the photographic field.

The silver-based photographic systems have been the oldest, most consistent processes in use in photography. The applications of other metal salts will now be examined.

Metal, Nonsilver Image Processes

Iron Sensitizers

The use of iron-light sensitive compounds for the image-forming process has examples in two notable processes. The cyanotype exemplifies direct application with the iron compound directly forming the final image. The other application is one in which an iron compound is the sensitizer and it reduces an associated metal salt such as platinum to form a platinotype.

The cyanotype, or blueprint process, is one of the earliest of the iron sensitizer processes; Sir John Herschel described this process in 1842. The platinotype was invented by William Willis and patented in 1873. The only other process of note with an iron sensitizer is the kallitype, an iron sensitizer which reduced a silver image as the final product. This was originally labeled by Herschel as the Argentotype in 1842 and it reappeared as the kallitype in 1889.

Other Non-Silver Processes

Chromium Sensitizers

The remaining group of processes to discuss are the bichromated colloid processes. The processes in this class utilize a dichromate salt as the sensitizer, and are associated with a colloid that is tanned or hardened in proportion to the light exposure received. The image-forming components tend to be natural pigments rather than pure metallic chemical salts precipitated *in situ*. This tanned image is a relief image, and the three-dimensional quality is often visible when viewing the print in raking light.

The first productive experimentation with a photographic chromate system was realized by Mungo Ponton in 1839. Talbot established the light sensitivity of potassium bichromate and gelatin and obtained a patent in 1852. Alphonse Louis Poitevin evolved a number of applications of chromates and organic colloids; he obtained patents for a carbon process and a lithographic process based on dichromated colloids in 1855.

The development of other dichromated colloid processes continued and included the pigment processes such as the carbon transfer process by Joseph Wilson Swan

in 1864, the ozotype by Thomas Manly in 1898, which evolved into the carbro process, and oil (W. de W. Abney 1873 and G. E. Rawlins 1905) and bromoil processes (E. J. Wall 1907 and C. Welborne Piper 1907).

This overview of the principal photographic processes has been presented to provide an introduction to the processes that will be discussed in the other chapters of this book.

The next topic to be examined is the proper handling of artifacts—since the greatest damage inflicted on collections of materials, including photographic artifacts, occurs when people handle them.

Examining and Handling Photographs

EXAMINATION

Photographs are examined by different professionals for different reasons. Conservators' examinations usually relate to the physical condition and chemical compositions of the materials that make up the photograph. Curators and researchers examine photographs to resolve detail and determine content that supports art historical points of view.

Examination Goals

Examination techniques used with photographs are similar for all of these groups. The goals of examination are to resolve points concerning the processes of fabrication, and to identify problems in the collection. Accurate identification and documentation of the photograph, including provenance, fabrication technique, and artist, can often be resolved by the conservator and the curator working in concert and will form the cornerstone of the catalogue and information-retrieval record.

The curators and their staff will also examine the photograph to identify elements of a more subjective, aesthetic nature. The archivist may spend time attempting to resolve associated features within the visual elements, such as period, clothing, styles, or geographical locations.

The conservation staff concentrates on the physical and chemical conditions of the photograph. The resulting conservation examination report can resolve questions associated with the fabrication and postfabrication treatments that photographs have been subjected to. The treatment proposal, originated by the conservator, is based on this examination report and the other information that has been assembled.

Nomenclature

The general photographic artifact we will discuss is exemplified by a modern, fiber-based, black-and-white print. (Figure 2.1) The major components of this model include the following:

The Binder or image carrying layer

This is a gelatin emulsion layer in which the image-sensitive silver salts are suspended and which after exposure and development appear suspended in the binder, above the support layer of the print when viewed. This binder layer is common to most photographs and historically comprises organic binders other than gelatin, including gum arabic, albumen, collodion, or starch.

The Image

Most images in contemporary photographs are either filamentary silver grains or organic dyes incorporated into the print emulsion binder. Silver, particularly in the filamentary form, is relatively stable chemically. The organic dyes, particularly of color materials, tend to vary in chemical stability from product to product; in general, they are not stable.

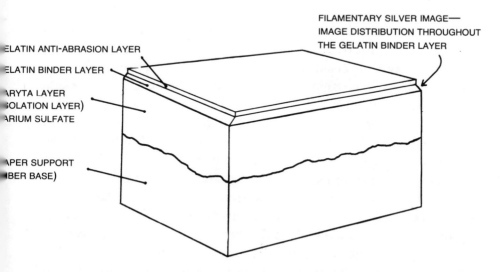

FILAMENTARY SILVER IMAGE—
IMAGE DISTRIBUTION THROUGHOUT
THE GELATIN BINDER LAYER

ELATIN ANTI-ABRASION LAYER

ELATIN BINDER LAYER

ARYTA LAYER
SOLATION LAYER)
ARIUM SULFATE

APER SUPPORT
IBER BASE)

Fig. 2.1 This idealized cross-section illustrates the multi-laminar structure typical of most of the modern photographic print materials. The fiber based print material is being displaced by the resin coated or RC papers.

The Support or Base

The support of the contemporary photograph is usually paper, or plastic laminated paper for prints and plastics for negative materials. There have been four principal support groups—metal, glass, plastic, and paper. The photographic process, particularly with the emulsion processes, lends itself to coating and application onto a wide range of support materials. Historically, the record includes collodion on leather and silver on cloth or wooden supports.

The Subbing/Baryta or Isolating Layer

The evolution of this major, structural component—either as an adhesive for plastic supports or as an isolating layer between the support and the image-carrying layers of paper supports—leads to the evolution of manufactured products in which the binder has been bonded to the support with a distinct layer. In prints, this intermediate layer is referred to as the baryta layer. The purpose of the baryta layer is to reduce the textural interference of the paper fiber base from showing through the transparent binder layer, thus reducing its capacity to resolve the finer image details. Initially, this layer was composed of barium sulfate bound in gelatin. Contemporary practice, however, makes use of an application of titanium dioxide. Both of these white pigments are applied to the paper or plastic support base prior to coating the light-sensitive emulsion. This layer can also be textured to provide different types of surfaces presently available.

The ''subbing layer'' refers to plastic supports and is an intermediate adhesive layer designed to assist in coating and adhering the gelatin binder to the plastic support. For the earlier plastic base supports, such as cellulose nitrate or cellulose acetate, the adhesive mixture was composed of gelatin dissolved in water in which a solvent for the plastic base was included, usually methanol. When this mixture evaporated, a thin layer of gelatin was deposited in the slightly etched plastic base, providing the tooth for the gelatin binder layer coated on it.

This intermediate layer is missing in the structure of the earlier historic photographic processes and to a degree it represents the interface between manufactured photographic products and the photographer's hand fabricated materials. The albumen process represents the transition in manufactured processes on paper supports, with the early 1880s as an approximate benchmark or cutoff point. The subbing layer is associated only with the manufacture and production of plastic supports.

General Descriptive Vocabulary

Conservators use a number of terms to describe photographs. This section explains some of the common terms, which may be repeated as a component of chapter 3 on deterioration.

Fading

Fading is the general loss of image density due to deterioration with time. The processes of fading are complex and may be interrelated with several different mechanisms, but in general the result is a loss in the image's density, that is, covering power or intensity. In the case of silver-based images fading is represented by a conversion of the metallic silver image to a yellow silver sulfide compound which has less covering power. This reaction also involves the conversion of two silver grains, from the image, to form *one* silver sulfide grain, and this also contributes to the reduction of metallic image silver.

Yellowing

Yellowing usually involves the conversion of the image highlights into a yellow stain. The deterioration in the case of the albumen print is represented by the formation of a silver sulfide in the nonimage print areas because of the absorption of silver by the albumen layer during sensitization. This silver is not removed during the fixing step and it reacts with sulfur compounds to form a yellow highlight stain.

Yellowing can also be associated with the fading reaction that occurs in a shadow or midtone area. The use of hygroscopic paste adhesives or rubber-based adhesive cements will result in the image silver being converted into the yellow silver sulfide.

Mirroring

Mirroring is a complex process in which image silver is converted to an ionic form, and migrates to a boundary layer, or surface, where it is reduced back to metallic silver. The gelatin emulsion processes are most prone to this type of deterioration and it is seen primarily in the print shadow areas of gelatin silver prints. Mirroring is also called sulfiding.

Tears, Losses, and Creases

These terms are used for physical problems related to the photographs and are self-explanatory. Tears are represented by a total separation of the support or

binder in the areas of the tear, while a crease is a deformation of the support or binder without that layer being torn. A loss is an area where a fragment is missing; there could be a hole or a void.

Blistering and Frilling

Blistering and frilling represent two forms of physical deterioration associated with gelatin emulsions. Blistering tends to be a local, bubble-like lifting of the gelatin emulsion away from the support, while frilling is composed more of a lifting of the gelatin emulsion over a larger area.

These are a few of the terms used to describe the chemical or physical damage a photograph might display when examined. They should be used to describe problems with the artifacts in your collection. From time to time a situation will arise that is not described by the terms in general use. In situations like these, avoid the temptation to introduce new descriptors. Call a colleague and see if the terms are already in use. Changing basic nomenclatures keeps us from collaborating and could introduce confusion.

Examination Methods

Visual Examination

Visual examination of the photograph is the most common method of examination. This includes both overall as well as close, detailed examination of the surfaces, supports, and image components that make up the photograph. The methodology can also include different light sources and viewing angles; in this chapter it will be built on to include examination with aids of one sort or another, including magnifying glasses and low-power microscopes.

The primary function of this type of examination is identification. This includes process identification, identification of the chemical and physical condition of the photograph, and thus the state of its deterioration and also the presence or possibility of alteration.

To examine and observe features properly requires light, of particular intensity and color. The kinds most easily available are either natural daylight, fluorescent, or incandescent sources. The primary feature of these is their intrinsic color. Daylight is blue and continuous, while incandescent light is yellow, and fluorescent is variable and discontinuous. Your capacity to see color differences and differentiate between stains or colored components in the artifact is enhanced by

being able to alternate from one source to another and thus catch variations by virtue of their changing contrasts. Ideally, the examination area would include mixed light sources; you can add flexibility by being able to control both intensity and color fidelity. Fluorescent lights may also provide a contrast, but the spectral distribution of any given lamp may not show some relationships because of the discontinuity of the fluorescent light's spectrum.

Close examination with the unaided eye is limited to only an intermediate range of a few inches from the object. The ability to see details accurately and minimize eye strain necessitates a low-power magnifier or, if possible, a stereomicroscope. This examination of the photograph's surface is very helpful in identifying the subtle surface topographic variations. Texture and surface irregularities may provide key information on the fabrication technique used or even confirm a particular deterioration feature that is a function of the particular photograph and process. The maximum relief information from a surface occurs when the light used for observation is low and oblique to the surface being examined. This light is called oblique or raking light.

Another aspect is the quantity of light available for use during examination. The light intensity should be high enough to insure that subtle differences in tone and shade can be differentiated but are not overpowered and lost. Different light sources must have similar intensities to insure that comparisons made by changing or alternating the sources don't result in blinding due to intensity differences and persistence of vision. Fiber optic light sources are ideal as a tungsten or incandescent light source.

The use of magnifiers to assist in examination represents the next level of discussion. This technique is required because of the inability of the human eye to resolve the finer details at the macroscopic and microscopic levels. There are a number of different auxiliary examination tools available for use with this technique.

Magnifiers represent the first and least expensive group of equipment items. The power of magnification ranges from a few power ($3 \times$ or $4 \times$) to compact models that are capable of $40 \times$ or more. These units tend to be hand-held items, inexpensively priced, and easily available through photographic and hobby shops. The higher power magnification units often include battery-operated light sources that illuminate the particular area of the print under examination (Figure 2.2).

These magnifiers often require that they be placed directly onto the surface being examined. This is an undesirable situation, because the photograph's surface could easily be abraded and damaged by the movement of the magnifier on

Fig. 2.2 The use of a hand-held magnifier, preferably with a light contained within it, is useful for examination of the print surface. This magnifier is available from Hoffritz (NYC), and allows for low power examination of this cyanotype print without contacting or resting on the print's surface.

the surface. There are two solutions to this problem: either use a small sheet of Mylar between the surface and the magnifier or reverse the magnifier and hold it above the photograph during examination. In the latter case the focal distance of the magnifier will usually be a little greater and the magnifier will not contact the surface

The next level of macroscopic/microscopic examination includes more expensive equipment, exemplified by stereomicroscopes. These instruments are low- to intermediate-power stereo binocular configurations that assist in examination, going further than the hand magnifier. The power is higher and the optical quality is usually better when one is using a stereomicroscope, but the most important fact is that you are examining the surface with stereo vision and the smaller details that might be lost in mono viewing are readily resolved (Figures 2.3 a & b).

The various intermediate internal layers of some photographs will often be possible to identify with the stereomicroscope, while the hand magnifier may only resolve internal structures in a few cases. The identification of processes is greatly enhanced by the use of a stereomicroscope.

All of the examination methods to this point have been visual, nondestructive ones without the need to sample. The need to resolve more about the photograph might require analytical methods that require a sampling of the photograph. This

Fig. 2.3a The use of a stereo microscope provides greater magnification and resolution of the photograph's image. The cyanotype image in *Fig. 2.3b* is contained within the upper layer of the paper support. There is no binder and the lack of sharpness is due to the fact that the paper's fibers are clearly visible and part of the image structure. Magnification is approximately 60X.

is generally not a course of action to be used unless the information is vital. Sampling and spot-testing should not be applied indiscriminately, and must be applied by trained professionals.

Specialized Techniques

Specialized examination techniques include changes in the configurations of light sources and in the radiation wavelengths of these sources. These changes might include light emissions in either the ultraviolet or the infrared regions of the spectrum. The observation may not be direct, but it could also make use of the fluorescence or absorption properties of materials present in the artifact, which, in turn, assists in process identification. The recording of these features may also be nonvisual and includes photographic recording methods on film as well as specialized instruments designed to record wavelengths of light not visible to the human eye.

The use of ultraviolet light during examination is an example of using a new, modern light source. The examination for active microorganisms, such as molds and fungi, which fluoresce under ultraviolet light, is an excellent and rapid method of monitoring fungal infestation of cellulosic and protein materials.

The same ultraviolet source will detect the presence of UV brighteners used

in most modern photographic papers. The brighteners are added to provide a brighter and whiter base to view the image against. The amount of deterioration that an albumen print has gone through can also be estimated by examination using a UV light source, since this changes as the albumen binder deteriorates.

The use of scientific instruments and their application to photographs are providing new sources of information to conservators and curators. The definitive identification of many of the nineteenth- and twentieth-century photographic processes is now possible by the nondestructive use of instruments such as the xray fluorescence spectrometer. This instrument has an xray source that excites the electrons within the sample to fluoresce. This fluorescence is characteristic of the type of inorganic materials that comprises the photograph, particularly the image, and identification is easily confirmed by examination of the elements detected in the spectrum.

This type of analytical method is illustrated in Figure 2.4. The spectrum is from a cyanotype print and the iron peaks are clearly visible, marked with the letters Fe. The sensitivity of this technique is such that it can help identify toners and some of the other additives that were used. XRF cannot identify the organic components present. The identification of organic dyes and organic binders would require another type of instrumental technique, such as infrared spectroscopy.

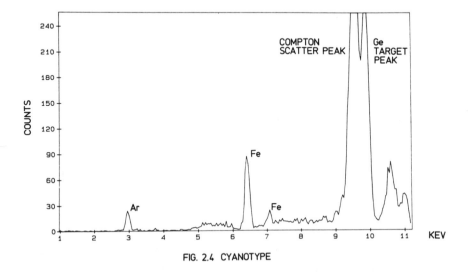

FIG. 2.4 CYANOTYPE

Fig. 2.4 This spectra of a cyanotype was obtained from an XRF instrument. The strong iron peak, labeled Fe, is representative of the cyanotype image. The peak marked Ar or argon is present in the air around the print during the examination.

Infrared spectroscopic analysis provides information on the organic components present and, to a lesser degree, some of the inorganics. The source in this case is infrared light used in an instrument configuration that requires sampling of the photograph. The use of FTIR as the infrared technique requires only a minimal sampling to be taken, thus reducing the ethical problems associated with the removal of a portion of the photograph.

These techniques are applied primarily by professionals, usually working as conservation scientists. The use of these techniques in the average collection will be minimal, but knowledge of their existence could provide an investigative avenue to a person in special situations.

HANDLING PHOTOGRAPHS

Much of the physical damage that can be observed on photographs has occurred during handling. The goals of both preservation and conservation are to minimize deterioration. This can be achieved by promoting handling practices and techniques that prevent physical damage to the photographs during use.

Often the first interaction people have with photographic materials is based on limited practical experience. The photographs may be an unorganized collection, a recent acquisition still stored in original, archaic housings, or they may exist even in unusual configurations that pose unrecognized problems. Incorrect handling in situations like these could result in damage to the photographs.

One example of this type of situation is a cracked gelatin glass plate negative in a negative envelope, which has been kept in a collection of unprocessed material. The gelatin binder is still intact, and in fact is holding the entire piece together structurally. A person's inability to assess readily ·the condition of the plate because it is in an opaque envelope could result in ·his removing the plate without supporting it properly, and causing the crack to break open under the weight of the glass. When this occurs the gelatin binder will be torn, and it tears in a manner and pattern completely different from the pattern the glass plate cracks. In this case the damage to the gelatin binder can include abrasion and loss of those pieces of the gelatin emulsion that extend over the glass edges. As a result, the negative, when reassembled, may have a permanent scar that coincides with the break on account of the voids and losses resulting from abrasion that prints darker in tone.

A second. example results from the common practice by photographers of

placing a contact print into the storage envelope with the original negative. This practice should never be employed because the transfer of residual chemicals from one to the other can result in deterioration of one or both of the photographs. In the case of a cellulose nitrate negative being stored in the same envelope as the contact print, the contact print will become acidic and brittle with time. This brittleness will not be apparent by visual examination alone, but the slightest flexing of the print, particularly during removal from the envelope, could result in the print cracking and breaking.

These occurrences are common, and it is possible that even skilled staff members may find themselves in difficult situations where the inability to define clearly the problems intrinsic to the situation at hand can result in damage due to handling.

On the other hand, an established and organized collection might suffer handling-related problems due to the addition of new staff, people unfamiliar with the collection-operating procedures, and the functioning characteristics of the various housings used in the collection. Damage in these cases might occur through procedural ignorance and a lack of proper instruction. These situations can easily be avoided by providing proper supervision and guidance.

When dealing with new collection situations, particularly newly acquired materials, or when items are still in their original housing materials, the handling and preservation problems are resolved by the application of proper examination, cleaning, and appropriate housing procedures and treatments.

Many of the points that have been made in this section are self-evident and commonsense instructions. The day-to-day pressures that we work under and the familiarity with which we regularly handle materials may cause us to overlook such procedures as time passes. Such procedures should be recalled periodically to insure that materials are always handled in a watchful state.

The Preservation Work Space

The area chosen for the examination, sorting, cleaning, and rehousing of artifacts should be free of other objects and collection materials. Clean and dirty work areas should be segregated, clearly defined, and dedicated to their separate tasks. Photographs that have been properly cleaned and housed should neither be returned nor placed in areas used for dirty work activities.

The dirty work space should have a supply of clean, light-colored scrap paper on the working surface. This allows the regular replacement of the paper as its surface becomes dirty and soiled. The quality of the paper is not a prime con-

sideration in this case since the dirty photographs and the paper are in contact with each other for only a short time. Papers appropriate for this task include unprinted newsprint or inexpensive artists' sketch paper.

With this approach, the area in which photographs are initially examined, cleaned, and prepared for integration into the principal collection storage environment, will minimize the contamination of processed items already in the collection.

Initial processing and examination will reveal cases of insect and mold infestations. The identification of these occurrences will require immediate treatment. Segregate these items and follow the instructions on page 85 for fumigation, fungus removal and stabilization.

The clean working space should include sheets of 4-ply matt board as the temporary working surfaces on which photographs can be laid. The matt board should be appropriately sized, larger than the overall photograph by several inches on all sides. The quality of these boards as well as any other associated papers and tissues must be high, because they will be used as supports for the photographs.

Personnel Etiquette

Anyone dealing directly with patrons, researchers, or other staff members should identify personal traits that might compromise the photographs under use, and so help to eliminate certain problems.

An example of a personal habit that compromises an artifact during handling includes people who lick their fingers prior to turning book or album pages. The transfer of saliva, or even lipstick, to the photograph can cause irreversible damage. Another example includes people who, after touching or rubbing their skin, then proceed to handle artifacts. The nose, forehead, ears, and eyelids are examples of areas from which greasy deposits can be transferred to fingers and gloved hands, which, in turn, are transferred to the photograph.

Cleanliness in and around the photograph in examination areas is essential. People should be encouraged to wash carefully and dry their hands at regular intervals during each work period. This will insure that dirt, perspiration salts, and greasy, oily deposits are regularly removed from hands. It will also increase the utility and life of gloves worn during handling.

People who will handle materials should avoid using hand creams or lotions since these products contain oily chemical substances that can stain and damage

the photographic image, binder, and support. The use of scented soaps should also be eliminated. A relatively pure soap, such as Ivory, should be used in washrooms associated with collection use areas.

It is also imperative that hands be carefully washed and, after washing, dried to insure that all excess moisture has been removed. Difficult areas such as the top and back of the hands and between fingers require extra care and attention.

Patrons and staff who have sweaty, clammy hands *must* wear gloves. Transference of salts and greasy oils can be reduced, and, in many cases, eliminated by wearing the appropriate kind of gloves or finger cots. These will need to be changed at regular intervals when they have become dirty or contaminated.

The Use of Gloves

Your fingers represent the primary contact point between yourself and the photographs being handled. Minimizing these contacts will reduce damage. Even with gloves on, avoid touching the surface of the photographs. Disposable cotton gloves (Kodak supplies them) are the most common gloves used to protect photographs from contact. Cotton gloves are comfortable and allow heat dissipation. However, one problem associated with cotton gloves is that they soil easily and require regular replacement. The soiled gloves can be laundered, but they tend to separate along the seams after washing.

Cotton gloves are appropriate for patrons and staff members *not* involved in handling operations that require dexterity. A specific case is the routine handling of artifacts by patrons in the patron access areas and staff members paging, sorting, and rehousing artifacts that have already been cleaned and housed within the collection environment.

Rubber latex or vinyl gloves are also used. They can be washed and reused. Retalcing the glove interior on a regular basis is all that is required. The problems with these gloves are that they are uncomfortable to wear because heat build-up occurs inside the glove and the loss of tactile sense prevents the possibility of conducting delicate work.

The most common problem with vinyl gloves is their poor fit. They often have surplus material bagging at the fingertips. These gloves should only be worn by staff members involved in gross handling operations of dirty materials—for example, the preliminary sorting of newly acquired materials that are particularly dirty.

The last type of glove material found in general use in collections is made of nylon. The weave is loose enough to allow heat dissipation, but the gloves are

generally warmer than cotton. The transference of contaminants from hands and fingers occurs more readily here because they build up in the glove's open weave, eventually reaching to the artifacts by direct contact. The gloves wash well and last much longer than cotton gloves. Nylon gloves are ideal for staff members who do not spend extensive periods of time with the collection materials and who do not have problems with hand perspiration. These gloves are appropriate for patrons and researchers working in limited access applications, such as viewing and handling of photographs which have been housed specifically to minimize direct handling, for example in matts or Mylbord-L housings.

The wearing of gloves by staff and patrons also helps to instill a conditioned response of respect. Attention of both staff and especially patrons is brought to the fact that these materials are considered valuable enough to warrant wearing gloves.

Criticism of the use of gloves includes the loss of tactile sense and a corresponding decrease in the confidence level associated with the handling of photographs. This situation generally occurs with only a handful of delicate items. In most cases it can be overcome by modifying handling procedures or by the use of an appropriate housing style. Most difficulties are bound to occur when new or novice staff members or patrons use the collection. Specific artifact problems and how to deal with them are discussed in Chapter 4, Cleaning and Stabilizing Photographs.

The situation most often observed and commented upon by staff is the conservator handling photographs during treatment. In this case the need for tactile sensitivity to insure that the treatment steps are properly conducted often precludes wearing gloves. The conservator should wear gloves in noncritical situations as well as when the treatment environment dictates the need for protection. The application of organic solvent baths during a conservation treatment step represents such a case.

The use of gloves is often a debated point. The rule of thumb should be to wear gloves whenever possible, remove them if the loss of tactile sensitivity might endanger the photographs during handling, and replace them when they get dirty. The use of auxiliary supports, and sound handling methods, should provide clear guidelines for the user.

Finger cots may provide a solution to the handling problem if the photographs contact only the cotted finger tips. These cots are available in latex. The talc-free type, normally used for electronic assembly and computer clean-room applications, are preferred to the talc versions. The cots are much cooler to wear,

and except for situations requiring full dexterity when one's entire hand is used —including palms—finger cots are a viable alternative to wearing gloves. Fisher large finger cots, talc-free, 10–002C are recommended (Figure 2.5).

Associated Equipment

Proper handling and examination of photographs require a host of associated equipment. A rigid sheet of Plexiglas is helpful as a support for photographs during handling and transportation over short distances. These sheets are referred to as auxiliary supports because the weight of the photograph and any stresses to it are absorbed and displaced by the Plexiglas supports rather than the photographs themselves.

The Auxiliary Support

The auxiliary support provides a rigid surface to work on; its primary purpose is to minimize damage to the photographs during examination. For example, a broken glass plate can be placed on it and after cutting open the envelope or enclosure can be treated with minimal movement of the broken pieces. This procedure is described in Chapter 4, Cleaning and Stabilizing Photographs.

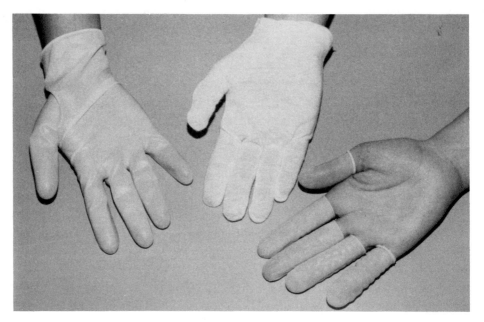

Fig. 2.5 Three forms of protection for photographs during handling. The latex glove, upper left, the cotton glove, middle and finger cots, lower right.

The auxiliary support also assists in turning over a photograph with minimum risk of slippage during lifting. It is also used to transfer an item from one surface to another, for example a brittle print to a new support surface. In this case, the new support will be thinner than the auxiliary support and thus the transferred piece will drop through a small, controlled distance to the second support surface. Figure 2.6.

In the case of a glass plate an edge is slid over the edge of the auxiliary support, allowing a firm grip to be obtained. For a brittle print, the pieces can be slid across the auxiliary support onto a new stabilizing support without applying stress that could crack or break the print.

Glass is not used as a secondary support because of its weight and its brittle nature. Plexiglas is light enough to allow the use of large sheet sizes, rigid enough to provide support, and can be washed and dried after use. Sizes should correspond to the more popular photographic format sizes and the next larger size should be used for any given photograph.

Several of the smaller sizes should be kept available for immediate use when handling or moving brittle or delicate items. A smaller number of the larger sizes are kept on hand for use since the larger sizes of photographs tend to occur less

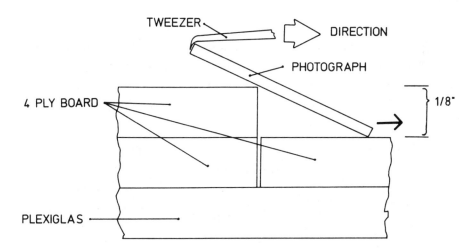

Fig. 2.6 Dropping a photograph through a short distance from one elevation to another. The use of auxiliary supports will allow a photograph to be moved, handled and manipulated without subjecting it to stress.

often. Remember, two hands are required for handling all supports, including the smaller formats.

Carts

Carts are used for transportation between rooms. All oversized materials that can't be handled safely, even with two people, and all brittle and delicate materials, must travel on a cart even when moving just within the room.

The features of the cart's construction that need to be considered include large diameter, shock absorbing wheels that will absorb shocks and roll over slight bumps and elevation differences. The cart should have horizontal storage shelves that are small enough to permit their movement and use in the storage areas but large enough to deal with the transportation of oversized items. For the movement of some oversized photographs it may be necessary to have an angled surface on the cart to lean them against. This will allow the cart to negotiate the doors and shelves of the storage areas.

Carts should be fabricated from metal, not wood. The finish used on the cart should be stainless steel, but other metal fabrication can be used if it is properly covered and finished. Baked enamel and epoxy paint finishes are preferred for painted or coated finishes.

Tools and Aids

Tweezers

Two styles of tweezers are particularly useful for handling delicate or brittle photographs. (Figure 2.7). The first is commonly used by stamp collectors. It has a matched pair of tips, which are formed into two large, flat, plate-like surfaces. These are perfect for picking up pieces of broken prints or emulsions

SPATULA TIP

SLIM DIAMOND TIP

Fig. 2.7 The most useful tweezer profiles. The flat, spatula type is ideal for moving pieces back and forth because it minimizes the stresses put on a photograph. This type of tweezer is also used by philatelists. The second profile is a curved one useful for pulling small pieces into position during stabilization.

without causing further damage. This particular item is available from Conservation Materials, Ltd., as spatula-tip tweezers. Their paper tweezers are also quite useful and are also recommended.

The second style of tweezer, the slim diamond tweezer, also available from Conservation Materials, Ltd., is quite different in shape. It has a pair of tips that are curved and slightly pointed. This tweezer is handy for sliding pieces of brittle print or emulsion from one surface to another.

Book Cradles and Book Snakes
The book cradles and book snakes described in this section are available from Conservation Materials, Ltd. These items assist in the handling and viewing of bound artifacts, particularly those that have been tightly bound and do not open flat. They are particularly useful for photographic albums, many of which have large, oversized formats.

The book cradle provides protection and support for the volume during its use and the snakes hold the pages open without damaging them, freeing the user's hands for note taking. The advantage of using these tools is that the volume page can be observed and note taking can be undertaken with both hands free (Figure 2.8).

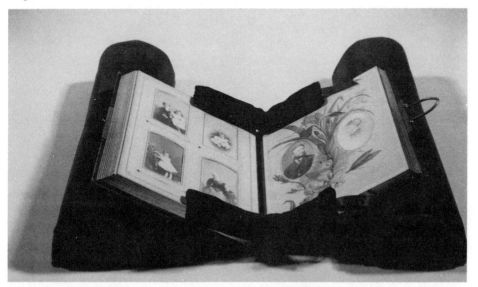

Fig. 2.8 The cradles have three pieces, two arms to support the book covers when open and a flat spine piece to support the spine. The use of book snakes assists in holding down the album pages.

Anchoring with Weights

Often it will be necessary to anchor an artifact to prevent its sliding or slipping. The procedure is used and described in the section on cleaning in Chapter 4, as well as during the hinging of a photograph into a matt. The weights that are used are not placed directly onto the surface. A piece of blotting paper is first placed onto the photograph and a Plexiglas or glass rectangle is placed on the blotter. The blotter is the same shape as the Plexiglas or glass and slightly larger in size on all sides. The Plexiglas or glass edges must be rounded to prevent damage from sharp edges. The weight is then placed on top of the glass or Plexiglas (Figure 2.9).

Procedural Aids

Orientation

Newcomers to the collection require orientation and instruction. Handling photographs from the collection should be an integral part of any orientation program for patrons and new staff members. The patron needs to be aware of the various types of housings that the collection will be presented to him in, and what can

Fig. 2.9 The weighting down of a photograph utilizes a soft blotting paper, laid directly onto the photograph, a piece of glass with rounded corners and smaller in size than the blotting paper and a weight which has a soft covering material and no sharp edges.

or cannot be opened and closed by him, or done by him to the housings and photographs.

It may also be necessary to explain the use of some of the aids mentioned in this text if they are being used within the collection environments. The use of a slide/tape presentation is one way of providing an orientation to the patron; also, some specific instructions by staff will help, while the patron is using the materials in the collection reference area.

The access to damaged or deteriorated materials in the collection must be screened by professional staff prior to release to a patron. The situation may arise in which materials are not paged because of their poor state of preservation and this step may have problems associated with it that can only be resolved by a senior member of the staff.

Traffic Reduction
The single most important step in the preservation of any given photograph can be achieved by providing either a copy or facsimile of the image or by providing another type of representation, perhaps an electronic one. The use of this as the patron's first point of access to the collection may satisfy his needs without handling the original directly.

In situations where the original still requires direct access, the housing and preparation of the artifact for use by patrons is the next level of control. The various options available in this case are outlined in Chapter 6.

Commonly Found Artifact Configurations
Photographs tend to be processed and placed into a common range of storage housings, and it is helpful to understand the features associated with these housings because they can conceal problems that could lead to handling related damage. Familiarity with these storage housing styles and the functions they are designed to fulfill will minimize confusion during handling and use.

Photographs in Plastic or Paper Sleeves
The use of plastic sleeves to house photographic black-and-white and color negatives and color transparencies is now a widespread practice by photographers and collection managers. The quality of these plastic and paper-sleeve and envelope materials can vary considerably and the problems associated with these materials are discussed in Chapter 6.

These plastic products are fabricated in the form of sleeves designed to hold

single items in the larger formats (4×5 and larger), and pages to hold strips of the smaller formats, (120 and 35mm). There are special application sheets to hold mounted color transparencies as well as custom-designed shapes for specific types of photographic artifacts, including stereocards.

Many of these same styles of plastic sleeves can be found as paper products. The product quality of these sleeves also varies, but the problems are still chemical ones and involve the processing of the paper itself. The primary concern with the use of the paper envelopes is the quality of the paper fiber furnish used and the method of sleeve or envelope construction. Glassine paper envelopes must be eliminated because of chemical problems associated with the fabrication of glassine papers. See Chapter 6 for a more complete discussion.

Problems you might encounter when working with the different types of materials associated with a photographic collection can include ones where the photograph has adhered itself to the envelope or sleeve. Plastic sleeves, which have an area of adhesion between the gelatin emulsion and the sleeve, could trap moisture, resulting in ferreotyping. The moisture trapped within the sleeve has caused the local swelling of the gelatin and it has adhered to the plastic, usually under pressure from the balance of the materials in the storage container.

Deteriorated cellulose nitrate negatives also adhere to their envelopes and sleeves, particularly when they are plastic. The deterioration of the emulsion because of acidic decomposition products results in the gelatin binder softening and the photograph adhering to the sleeve. This situation can also occur with paper envelopes, but the ability of the decomposition products to escape through the paper reduces the chances of adhesion. The adhesion of a swollen gelatin emulsion to a paper envelope requires an unusual situation, such as a flood or fire-related disaster. The moisture or actual wetting of the envelope, due to the presence of water, swells the gelatin that adheres to the paper envelope as the package dries out.

If a photograph appears to be adhered to the walls of its housing container, DO NOT ATTEMPT TO REMOVE IT. Forcing an item in this condition will probably result in further damage; typically, the emulsion is torn from the support layer and this damage cannot be totally repaired. The adhered components can be separated by a conservator using a chemical treatment sequence for materials other than cellulose nitrate supports that have reached an advanced stage of deterioration. The gelatin binder may have reached the stage where it is water soluble and many of the treatment options can no longer be applied.

Photographs in Four-Flap Enclosures

This storage format is becoming more popular as a method of safely storing gelatin and glass plate negatives. The added cost is easily offset by the advantages of this storage housing, and the occurrence of this type of enclosure implies that the contained artifact has already been handled by competent people and has been documented, cleaned, and, if appropriate, stabilized.

Photographs in Print Albums

Prints adhered to or held in photographic albums represent a problem during handling. The problem is often due to size, but it can also result from the range of different types and configurations found within the album itself. It is common to find loose photographs and other related materials in the album that are not a part of the album page organization and structure. These letters, postcards and notes need to be kept with the album, but their existence in the album may be compromising the album's physical security.

The first step when handling an album is the use of a book cradle to provide support to the album. Many albums will display a spine that is damaged due to incorrect past use; it is important to minimize this deterioration by providing support to the album during use. Additional problems will become evident while turning and examining the album pages. Problems can include mounted prints that are loose and have slipped out of their window frames and are now embossing themselves on the print stored on the adjacent page. You will also find associated materials of various sizes stuffed loosely into the album; these may not be photographic. These include letters and postcards that may also be causing problem interactions with the photographs in the album.

The album and its problems are discussed further in Chapters 4 and 6. The most important step is the preparation of the album for use by using the book cradle—and if the pages will not lie open, the additional use of book snakes.

Photographs in Matts or on Mounts

Matted prints can represent items that have been prepared to address handling needs as well as for display. These housings function in such a way that there will be minimal related handling problems. The different styles of matts are discussed in Chapter 5 and the emphasis is on the appropriate matt style to be used for particular problems associated with the artifact. The example that occurs most often is a mounted photograph in which the mount itself must also be

accommodated. The sink matt is the style that best answers the needs of this configuration.

Matted photographs need to be laid flat during use and the room must be provided for the window board if it is to be opened in order to allow examination of the print (Figure 2.10). Do not lay other matts or materials onto an opened matt. The matted photograph will be hinged into the matt and you should determine the hinging method before you lift or turn the photograph over (see Chapter 5). Turning the hinged print over to allow viewing the back of the photograph or the back of the mount is a critical step, and this procedure is described in Turning Photographs Over, elsewhere in this chapter.

Mounted prints tend to be secure, but care should be taken to insure that they are supported properly. Many of the boards used to mount prints are made of poor quality materials that become acidic and brittle with time. In this situation the board will not be able to support its own weight if held in a corner with only one hand. Corners that break off can also break off a piece of the print mounted to them.

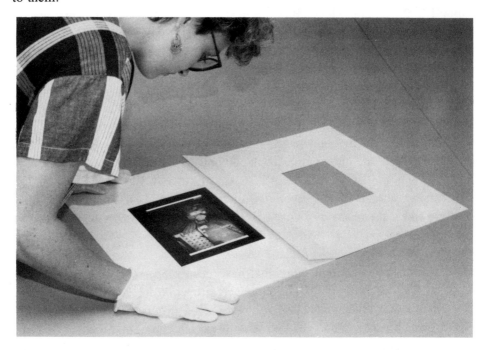

Fig. 2.10 The viewing of matted prints requires flat and open areas in which the matt can be laid down and the matt window laid down flat. Avoid laying matts onto each other or allowing too many items to be used in the same area.

Photographs in Frames
Unmatted framed prints that can contact the glazing could become adhered to the glass of the frame, and subsequent removal could result in physical damage to the image. This situation is similar to the adhesion of gelatin emulsions to plastic sleeves due to water or high humidity conditions associated with events such as floods or fire damage. The occurrence of an unmatted gelatin print contacting the glazing and adhering to the glass is at present quite common.

This situation can be treated by the conservator if identified before disassembly takes place. However, what commonly occurs is that the presence of small areas of adhesion is not identified by the person removing the glazing and the adhered areas are torn off when the print is removed. Close examination of the print through the frame glass prior to removal will help locate these areas of adhesion. The areas of contact are generally slightly greener than the adjacent, nonadhered areas.

Photographs in Mattboard Folders (Mylbord-L Folders) (L-F Folders)
This polyester and mattboard package, (Mylbord-L), provides a housing for materials as a substitute for the matt. The plastic upper surface allows the contents to be viewed without removal from the protective environment of the housing. The photograph may be removed but care should be taken when replacing the photograph, an operation which should be limited to staff, not patrons.

This folder style may not be appropriate for use with some photographs and the L-F folder is a substitute style. The mattboard support has a sheet of lignin free folder stock attached to it on the bottom edge using the 3M 415 double-sided tape. These folders are custom-made items and are described in Chapter 6.

These examples are the most common collection housing configurations but there are numerous others which are used to store artifacts. Many of these other configurations may have associated with them problems which are exacerbated by handling prior to treatment.

Removing Photographs from Their Housings
The removal of photographs from the containers and envelopes they have been stored in represents one of the most critical moments in the security of any photograph. Damage to the support, image, or binder can occur during this operation. The ideal is to minimize the possibility of this occurring while still providing access to the photograph for processing by staff. There will, of course,

be situations where access must be restricted or eliminated to insure the preservation of damaged or sensitive materials until a subsequent treatment can be applied, but, in general, the collection can be prepared to minimize physical damage during handling.

The removal of the photograph is undertaken only if the initial examination of the housing and preliminary handling have clearly shown it to be stable. An envelope that sags in an area when picked up suggests an instability, probably a broken plate, as does flaking emulsion falling out of an envelope when it is opened.

For photographs contained in conventional photographic paper storage envelopes:

- While holding the envelope in one hand, and supporting the weight of the envelope with the other hand, pinch the top and bottom sides of the envelope at the opening to allow visual identification of the contents (Figure 2.11).

- Observe the contents, particularly the emulsion, binder, or image-carrying side. Pull a short length of the photograph out of the container. Place the photograph down on a clean auxiliary support, image side up.

Fig. 2.11 Pinching envelopes must be conducted with a hand under the envelope since glass plate photographs may be contained inside the package.

- Slide the envelope away from the photograph with one hand while holding the photograph's edge with the other hand.

- Don't force the separation of the two if resistance is encountered. Damage resulting from forced removal is usually not reparable.

- If the contents of the envelope are heavy, and do not appear to be uniformly rigid, there may be a cracked or broken glass plate inside. Place the entire package down on a flat surface and proceed with the cleaning and stabilization procedures outlined on pages 88–89.

For flap-style enclosures the following is recommended:

- Place the enclosure down onto an auxiliary support positioned on or over a light box.

- Open the flaps of the enclosure and view the contents.

- This particular housing is used almost exclusively for photographs with transparent supports, such as when negatives, and a light box can be used to assist in viewing them (Figure 2.12).

Fig. 2.12 The four flap enclosure is transparent enough to allow the viewing of the negative on the lightbox. The photograph is not handled directly during this process and this increases the useful life of the artifact.

- The orientation of the photograph in this type of housing is image- or binder-side down for artifacts on transparent supports and, vice versa for opaque supports.

For plastic sleeves the following is recommended:

- Hold the sleeve in one hand and carefully pull out a portion of the photograph to determine which is the binder or image side.

- The small size and light weight of the types of photographs kept in these sleeves might tempt you to work without laying it onto an auxiliary support.

- Ideally you should extract the photograph from the sleeve just above an auxiliary support and lay it down on the support after removal from the sleeve.

For ornamental cases:

- Care must be exercised with these photographs because their removal can result in damage to the case at two different points: the hinge (which is usually torn or broken already), and the glued corners of the wooden box containing the assembly.

- Carefully insert the tip of a thin, narrow spatula or pallet knife between the wall of the wooden case and the metal-bound framed photograph (Figure 2.13).

This prying motion will place stress on the walls of the case and should be dissipated by moving the spatula down, along the seam and gently prying upward at a number of locations.

The removal of the enclosed photograph and its wrapper will allow identification of such things as the photographer's label, usually on the back of the assembly, and possibly some other information or items placed into the case by former owners.

The opening of the wrapped assembly containing the photograph requires considerable care and is described in Chapter 4.

For Albums

Different binding and album styles present situations that cannot be generalized, and the best, commonsense attempts should be made after studying and examining the particular album construction.

Fig. 2.13 The micro-spatula that is being inserted is used to pry the case contents up, out of the shell. The corners of the wooden case may crack and separate and care is required at this stage. Do not remove the case unless it is absolutely necessary.

The removal of photographs from the most common style of album is illustrated in Figure 2.14. The photographs in this type of album are mounted and require the application of a tetragon-shaped piece of cardboard or a palette knife to raise the photograph and/or its mount in order to allow it to be pulled out of the storage slot. This tool is slipped in under the photograph as shown in Figure 2.14.

The other major album style, which was used primarily for loose, unmounted prints, involves inserting the print corners into the album page where the page has been cut to allow the insert. This style of album page is generally available from one of the suppliers listed in the suppliers' appendix. The removal of the print corners can be achieved with either of these tools. Insert the flat edge and gently pull up and back while holding the edge of the print against the tool. This technique will help you slip the print's corners out of the album page.

The use of ''photocorners'' will be a common occurrence with historic albums that have been treated and reassembled or with contemporary albums. Cut the corners open to remove the photograph (Figure 2.15). The use of paper corners makes it easier to cut the corner than the polyester or Mylar corners. Do not attempt to remove the photograph by flexing it and pulling it out, and reinserting it by pushing it back into the corners. This usually results in considerable physical damage to the photograph at the corners.

There will also be albums into which the prints have been adhered directly to the album pages. These can't be removed. Attempts to do so will tear and skin the prints.

Fig. 2.14 The removal of photographs from album pages such as this will require the insertion of the palette knife under the photograph and mount and with finger pressure down onto the print's surface gently slide the contents out. Take care that the corners of the mount do not tear the album page during this step.

Fig. 2.15 The insertion of the scalpel point must be carefully undertaken and the blade should be inserted only far enough to cut an eighth of an inch at a time. Cut away from the print.

Oversized Materials

Oversized materials, due to their large size and considerable weight, will need two people to remove them from their storage enclosures and housings. If a second person is not available, find one before attempting to transfer an oversized photograph from its storage or use area.

Remember that the oversized storage boxes and containers will weigh more than expected because of the size of the housings required. It is important to keep the working height of these storage containers and boxes at a manageable level on storage shelving units. Ideally, the largest and heaviest boxes could slide off of the shelving just above the level of the transport cart shelves.

Turning Photographs Over

The need to turn photographs over for examination of the other side or because the image-carrying layer is not facing the viewer also needs to be discussed and outlined. The photograph should be lying on a clean auxiliary support.

For artifacts with rigid supports of glass or metal the following steps should allow them to be turned over with minimal damage:

Place the fingers of one hand against the edge of the photograph. Place the fingers of the other hand against the opposite side. If it isn't possible to grip the edge, carefully slide the photograph to the nearest edge of the auxiliary support and allow it to extend over the edge sufficiently to allow that edge to be gripped. Pick up the photograph and turn it over.

Be careful that the surface of the photograph is not damaged during this sliding step. Particular problems include items which have not been cleaned, and image binder or emulsion layers, like collodion, which have high sensitivity to scratching and mechanical damage.

For photographs on paper and plastic supports including brittle items up to about $8'' \times 10''$, damage can be minimized by using the following modification to the procedure outlined:

Begin by sliding the artifact off the auxiliary support onto another auxiliary support, a piece of board cut slightly larger in size than the photograph.

Place a second piece of board, the same size as the first, on top of the assembly to form a sandwich.

The photograph can now be carefully turned over, care being taken to insure that it doesn't slide out during the process.

This technique cannot be used with the larger sized photographs. The added weight of the larger photographs can result in sliding, and they may slide through the separation between the two sheets of mattboard.

For large pieces, the procedure is changed slightly by taping the sides of the package temporarily prior to the turning over motion and the assistance of a second person is required.

For matted prints, the following procedure is recommended.

Place the matt down on the table and open the matt window. Remember to clear a space beforehand that is large enough to accommodate the fully opened matt.

Place a piece of matt board the same thickness as the matt backing board, down against the matt's backing board. This surface will support the hinged artifact once it is turned over and laid down.

Place a sheet of quality paper across the seam between the two pieces of board and lay the artifact down on this piece of paper when it is turned over.

When the photograph is in a horizontal matt, place the paper across the window before turning the photograph over. It may be necessary to add a second sheet of matt board to the edge of the window matt if the photograph is large. The use of this sheet of paper will keep the surface from touching the window edge or falling through the window itself. This event could result in damage to the photograph.

One of the most constructive steps in minimizing damage to a matted photograph due to handling, is to note on the backing board (in one of the lower corners), that there is no inscription or information on the back of the print. This notation on the backing board, adjacent to the print beside its acquisition number, should reduce damage that can be caused by turning over the photograph, since it may no longer be necessary to do so to find information on the back.

In general, when handling the photograph without an auxiliary support, try to

hold the edges or on nonimage edge areas. Whenever you feel the photograph needs greater support, always use it.

Identifying the Image Side

The identification of the image-carrying side of a photograph is important to insure the proper identification of processes, by minimizing damage during handling and examination and to insure that the appropriate quality of materials is used for rehousing after examination.

The term emulsion is often used in a generic fashion to refer to the image-carrying-binder layer of a photographic artifact. The emulsion is a binder-layer containing the image (initially the light-sensitive silver salts) and is not found in all photographic processes. The convention that I will try to use in this text is binder-layer for all photographic processes that include emulsion processes. In situations where the process is uniquely an emulsion process the term emulsion may be used as well.

The binder, or image side, is the matt or semi-matt textured surface when viewed in a raking light. The glass and plastic supported photographs will have a smooth side and a textured or matt-image side. The carbon print is an excellent example of a textured image surface.

Paper and Metal Supports

The image-carrying surface on paper and metal-supported photographs is easily determined. It is self-evident because it is the image-carrying side and the condition of the photograph can be resolved directly.

Glass and Plastic Supports

The image-carrying layer on glass and plastic supports is more difficult to determine because of the transparent nature of the support. The image-carrying surface on these photographs tends to have a less reflective character when viewed in raking light. Raking or oblique light is used because it accentuates the surface relief of the artifact. The image-carrying surface shows slight differences in texture, while the support tends to be uniformly smooth and reflective.

The binder, the image or emulsion side, should be facing the observer during examination, but during storage should be rehoused in a manner appropriate to the photograph and its housing. The emulsion side of a glass plate negative in a four-flap enclosure, for example, should be face down.

When handling photographic artifacts, observe the following procedures.

- Work only in the designated areas. Eating, drinking, and smoking are not allowed in these spaces.
- Staff and patrons must wash their hands prior to working with the collection materials. Hand lotions and creams are *not* to be used and an appropriate pair of gloves *must* be worn.
- Always pick up a photograph with both hands.
- Large or heavy photographs must be used with an auxiliary support. Delicate and torn items also require the use of an auxiliary support.
- Heavy photographs enclosed in envelopes might be glass plates. Never stack these upon each other. If an enclosure sags when lifted, a broken plate may be inside. Lay it flat on an auxiliary support for examination and stabilization.
- Always remove the enclosure from the photograph and not the photograph from the enclosure.
- Don't force the separation of one item from another.
- Only pencils are allowed in the work space, and writing paper should be supplied by the collection staff for note-taking purposes.

3

Deterioration of Photographs

The conservation literature tends to deal with the topic of deterioration by mentioning two major concerns, *induced* deterioration and *inherent* deterioration. Induced deteriorative processes tend to be those that relate to the environment in which an artifact is kept and include exposure to temperature and relative humidity as well as use by individuals or the environment in which the photographs are exhibited and displayed. These variables are controllable and can increase the stability and preservation of the photographs.

Inherent deteriorative processes are often referred to as inherent vice, and involve the various components that comprise the photograph itself or that are associated with its fabrication processes. An example of this would include residual processing chemicals from the fabrication step, which, when combined with undesirable environmental conditions results in induced deteriorative processes: an increase in the rate of deterioration of the artifact. Another example might include the effect of differential deterioration rates of the numerous layers or components in a photograph that affects the whole, the interaction and inter-relationships of multi-component layers of a photograph with itself. Dye fading in chromogenic photographic prints is an example of this. These variables are generally uncontrolable, or, at best, only partially controllable.

Induced deteriorative processes may also include neglect or ignorance, which directly result in damage or an instability introduced to the photograph. Many of the images of daguerreotype plates were damaged by people who removed them from their protective ornamental cases. The daguerreotype image is susceptible to mechanical damage and cleaning by rubbing with a cloth will remove the image. Ignorance of the sensitivity of the image to physical abrasion resulted in the loss of the image—intentions being good—but ignorance prevailing.

The overall, general deterioration of a photograph and the rate of the deteri-

oration may be defined by the inherent vices associated with that photograph. They can be minimized by controlling the environment, reducing the impact of induced deterioration.

THE ENVIRONMENT AS A DETERIORATIVE PROCESS

The "environment" as used here includes chemical, photochemical, physical and biological processes of deterioration. The conditions we are most likely to understand are the physical processes, those associated with damage to the artifact, which might include tears and rips or losses and holes, usually due to ignorance or neglect. Chemical, photochemical, and biological deterioration tend to be medium or long-term processes while physical deterioration tends to be represented as a more immediate and apparent change.

Chemical and photochemical processes, and to a lesser degree biological deteriorative processes, are often discussed in the preservation literature. Chemical processes of deterioration and the rates of these processes are controlled by conditions of relative humidity, temperature, contaminated atmospheres, light and cycling environments, and are considered as part of the general environment of the photograph.

Deterioration and Process Identification

The manner in which photographs deteriorate is often characterized by the elements that make up the photograph. It is possible to define some photographic processes in terms of their fabrication steps, characteristic fabrication faults, and the nature of their deterioration. The use of observable deterioration features with other features, such as color, texture, and style, will assist in identification of different photographic processes.

Environment after Fabrication

After fabrication, elevated temperature and relative humidity levels, the presence of harmful gases in the atmosphere, or contact with certain types of material can lead to detrimental chemical or physical changes in a photograph (Figure 3.1).

These factors may also compound the effects of the first two conditions. For example, materials containing sulfur, such as rubber cement adhesives, in close proximity to silver images can produce a chemical conversion of the image to silver sulphide. This conversion is accelerated by high relative humidity and high temperature conditions.

Fig. 3.1 The tarnishing of a Daguerreotype plate is a common problem and can often be traced to the opening of the frame assembly and breaking of the paper tape sealer. The tarnish begins as a light brown and evolves through a number of colors to an opaque, deep blue-black deposit along the outer edge of the metal mat.

In general deterioration is seldom due to a single factor, but rather the result of several undesirable conditions compounding one another.

GENERAL ENVIRONMENTAL VARIABLES

TABLE 1 Deterioration examples

Chemical	*Physical*	*Biological*
–sulfiding of a silver image due to residual processing chemicals or atmospheric sulfur	–breakage of a brittle support, such as glass, or deteriorated nitrate film	–pitting of gelatin emulsions by fungi or insects
–stains of the support or binder layer due to residual processing chemicals	–the cracking of a binder layer due to contraction and curling during dry conditions	–discoloration of the image by insect and rodent feces
–the pitting of a binder due to the transfer of perspiration salts and grease	–tears and rips in paper supports due to poor preparation and handling	

Chemical and Photochemical Variables

Chemical deterioration tends to be a function of the complexity of the component materials comprising the photograph. The chemical properties of each layer and component have a defined stability or instability which in turn may change on the basis of chemical interactions with the other components of the photograph, other materials that contact it in an intimate fashion, or from the general environment in which it exists.

Humidity

Humidity and temperature act together and, as such, are usually discussed together. The relative humidity, however, is in general the more significant of the two in the case of photographic artifacts and materials. The relative humidity of the air in which a photograph is maintained is a measure of the amount of water contained in the air relative to the amount of water that volume of air could hold at that temperature when saturated with water. The lower the relative humidity, the dryer the air and the dryer the photograph.

High relative humidities result in high moisture contents in most photographs. This increases the rate of chemical deterioration because of the hydrolysis of the organic components as well as the mobilization of residual processing and fabrication chemicals from within the photograph.

Temperature

Temperature controls the rate of deterioration. The higher the temperature the faster the rate at which the photograph will deteriorate. One of the best examples of applications of depressed temperatures is the cold storage vault environments used by some photographic collections for cellulose nitrate materials; these were primarily to reduce the rate of evolution of decomposition in gases, which in turn attacked the silver image, or storage of color processes based on dye chemistries that fade or break down the dyes that comprise the images at a much slower rate—again because of reduced chemical rates of deterioration.

Low relative humidity, coupled with elevated temperatures, generally is less damaging to photographs than high relative humidity and lower temperatures. The ideal would be dry relative humidities, 30 to 40 percent, and ambient or slightly depressed temperatures, 65° to 70°F. The application of cool or cold temperature conditions may require considerations such as sealing the photographs prior to introduction into a cold environment and also staging or warming up

materials that have been stored in cold environments prior to opening them in ambient conditions.

Cycling Conditions

Cycling conditions are mentioned in the previous paragraph and should be discussed at this point. The combinations of relative humidity and temperature mentioned tend to vary in value and range with time; during the day, for example, if the temperature rises, the relative humidity drops, and, as the temperature drops, the relative humidity or water moisture content of the air increases, perhaps to the dew point. The tolerances, or the range of acceptable values associated with a particular environment, should always be listed with the recommended climatological norms.

The situation of varying conditions with time, and specifically the cycling of these values in a regular pattern, results in strains and stresses in many of the materials that comprise photographs. The ability of most photographs to absorb and desorb moisture is due to the fact that they are composed of organic materials—for example, paper and, to a lesser extent, plastics. Also the binder may be a very hygroscopic organic material such as gelatin.

The expansion and contraction of these hygroscopic organic materials—as their moisture content increases and decreases with relative humidity, and temperature increases and decreases—can result in physical or induced deterioration. The best example is a gelatin glass plate, stored in an attic for a number of years. The glass does not change dimensions to any significant degree with temperature increases and relative humidity makes no contribution to the glass at all. The gelatin binder, however, is a hygroscopic organic material capable of absorbing several times its own weight in water moisture. The elevated relative humidity results in the gelatin's expansion on the rigid glass support, followed by loss of moisture as the temperature rises and a contraction of the gelatin, again with no changes, results in the glass support. The result is usually a blistered and torn gelatin binder with memory stresses that interfere with the conservation treatments (Figure 3.2).

Contaminated Atmosphere

The air quality or the amount of oxidizing gases and pollutants in the air in the environment in which photographic materials are kept contributes to long-term chemical deterioration. The pollutants are generally thought to be external sources, but the possibility exists for internal sources, particularly in the form of *packing*

Fig. 3.2 This gelatin glass plate negative has blistered and released along the upper edge and right side. The tears that occur in the gelatin emulsion are difficult to repair and will show in subsequent printing of the negative.

materials such as rubber or foam materials, or in some cases associated materials such as mount boards, or even the photograph itself.

The components of greatest concern to us are sulfur-containing compounds, particularly in gaseous form, since a gas is easily distributed within a space and because it can diffuse through porous materials such as paper and to a lesser degree plastics. Sulfur dioxide and nitrogen dioxide are the primary agents produced in our urban environments. These gases are by-products of fossil fuel and gasoline combustion and they adversely affect photographs.

These external sources of oxidizing gases can be effectively eliminated by the use of appropriate filters in the building's air system. The regular inspection of the filters and a filter replacement and maintenance program is an important addition to the overall environmental control program.

Internal sources of pollutants may represent a more difficult situation to resolve. Internal sources include the chemical compounds already mentioned as well as several that may not be obvious. The ozone produced by electrostatic copy machines or Xerox machines is very damaging to organic materials, resulting in chemical attack more aggressive than most of the other gasses of concern to us. As a result the administrative functions of larger collections, particularly copying records and forms, should be isolated. The air return from these office areas should also be filtered to remove the ozone before re-mixing with the fresh air taken in and being returned to the various building areas.

When incompatible materials are in intimate contact with each other—for example, two different types of artifacts—deterioration can occur that affects only this small portion of the collection and generally does not involve the balance of the collection. The practice of photographers to store their exposed and processed photographic images in the same boxes and paper in which they were purchased has resulted in damage to the contained artifacts because the residual chemicals left in the papers and paperboard boxes from manufacture are attacking the image chemically. Paper products may contain high concentrations of thiosulfate, a sulfur compound, and chlorine. These chemicals are activated by high relative humidities and migrate or transfer to the artifact by contact, resulting in image changes such as the loss of image density as well as highlight staining.

The most important example of a photograph that can activate its own deterioration as well as that of other photographs in the collection with which it is stored is the cellulose nitrate plastic support, usually a gelatin binder with a silver image on a cellulose nitrate base. The decomposition products are temperature and moisture controlled and include nitrogen oxides and dioxides. These gases combine with the moisture in the gelatin to form nitric acid that turns the cellulosic support brittle and attacks the silver image, bleaching it. The decomposition products are gaseous and can dissipate throughout the collection, damaging other silver and organic materials and artifacts (Figure 3.3).

Fig. 3.3 This nitrate negative was stored in a plastic sleeve and has been bleached out in the bottom center area because of a build-up of decomposition gases in that area. These gases attack the image silver, bleaching or dissolving it.

Light

Light or photochemical deterioration tends to be the deterioration process associated with exhibition and display concerns. The trend in conservation has been to use incandescent light sources of low intensity with limited durations of exposure. These are improvements on the conditions to which artifacts were previously subjected. Light with high concentrations of blue and ultraviolet, such as daylight and unfiltered fluorescent, are more damaging to organic-based materials than inorganics; and the removal or control of ultraviolet light reduces damage to photographs that are placed on exhibition or used extensively by collections staff and patrons.

The sensitivity of contemporary color-dye materials is the most commonly cited example of photographic artifacts that are sensitive to photochemical deterioration such as fading or dye loss. The deterioration reaction rate can be reduced by lowering the temperature during storage, maintaining relatively dry environmental conditions, as discussed earlier, and by reducing the duration of light exposure and the intensity of the display light source.

The discussion surrounding the impact of light on photographs has recently been reopened. An attempt was made to assess the deterioration of photographs on exhibition—both color and monochromes—in conditions felt to be conservative and appropriate for museum-quality exhibitions. These recent investigations, as yet unconfirmed, have indicated that monochrome processes in pristine condition may change during exhibition in a manner similar to color dye materials and may also exceed the losses sustained by the color dye artifacts exhibited under identical conditions. The resolution of this research work is an important new aspect of the approaches we will take towards the exhibition of photographic materials in the future.

The selection attitude for the exhibition of photographic materials is often based on the quality of the image. The badly deteriorated image is aesthetically unattractive, and so those items in better condition are exhibited. The image quality of a photograph plays an important role in both the appreciation of the image while on exhibition as well as in its preservation.

Physical Deterioration

Physical deterioration tends to be related to the effects of the chemical deterioration on the artifact and its various structural components. The greater the number of components in the laminate structure of the photograph the greater the stresses

that build up during fluctuations in the environment and the resulting failure of the artifact's laminar structure may occur.

Physical deterioration often results from stress-induced failure that cannot be sustained by the photograph. It can also be due to inherent sensitivities of the artifact's composition materials or an acquired sensitivity due to chemical deterioration. The example of tears and losses due to the inability of paper-supported artifacts to sustain strains in handling is a case in point.

Glass-based artifacts are inherently brittle because of the nature of the support. The weight of a group of glass plates placed one on another is sufficient to crack or even break one of the plates if grit should be present between the glass plates. The best example of acquired sensitivity is acid-concentration build-up within a paper or cellulose nitrate supported photograph. The acidity results in an increase in brittleness of the support and a corresponding decrease in the mechanical strength of the support.

Physical deterioration tends to be a controllable component of the deterioration processes and tends to be less significant in its impact in the collection. Many examples of physical deterioration of photographs derive from chemically related or initiated deterioration.

Biological Deterioration
Biological deterioration can also be viewed as a component of environmental conditions and chemical deterioration. The ability of fungi to thrive in a collection depends on the presence of relative humidity conditions in excess of about 65 percent and ambient temperatures in the human comfort zone, greater than 70°F. Fungi also require a nutrient source that can be supplied by cellulosic support materials, but significantly more important is the presence of gelatin.

The appropriate elevated relative humidity and temperature will support the growth and propagation of fungi and the damage to the photograph that results is the consumption and conversion of the gelatin binder. The cellulosic paper support is attacked chemically, as is the binder and image by the chemical by-products produced by the fungi (Figure 3.4).

The ability to control fungal problems is simply a matter of controlling the environment. The contaminated materials can be stabilized chemically, but in the case of fungal attack on a gelatin binder the gelatin in the area of attack has become water soluble and thus treatment considerations must be carefully made.

Rodents and insects also pose problems, including the consumption of those

Fig. 3.4 The presence of gelatin as part of the photographic print or negative
provides a source of food for insects and fungi. The damage resulting from
attack by both of these results in permanent and irreparable damage to the
image. This print shows circular spots where insects have attacked the binder
as well as mechanical damage such as tears and scratches.

components within an artifact that provide nutrients. The example of silverfish
damage to gelatin silver prints or the corrosive chemical reaction of rodent by-
products can disfigure and discolor photographic artifacts because of their high
acid content.

Clean and controlled environments allow us to eliminate or control these prob-
lems successfully.

STABILITY OF PHOTOGRAPHS

General Structure

The stability of any particular artifact is related to its structure and the chemical and physical properties associated with those components. The general structural arrangement of a photographic artifact will include the image, a binder layer, on or in which the image is located, and a support for the image and binder.

The early photographic processes were simple structures and as such were less susceptible to problems associated to the interaction of these various component layers with one another. As the number of photographic processes evolved the introduction of secondary supports and adhesives occurred. The introduction of the manufactured photographic artifact made the relationships between components within the photograph very complex. Contemporary, manufactured photographic products are composed of the same basic structure and elements, but also include numerous, discrete layers usually associated with the image-fabrication process.

This contrast can be best illustrated by the three idealized cross-sections of a salted silver print (c.1840), a mounted collodio-chloride silver print (c.1890), and a SX-70 Polaroid print. (Fig. 3.5, 3.6, 3.7)

Deterioration of the Support

The support materials, in common use, and designed to carry the image, include paper, glass, plastic, and metal. The photographic process allows its application to virtually any surface, but these four represent the most common. Paper supports and their deterioration have been mentioned and include reaction with residual fabrication chemicals, the environment (including temperature and humidity), as well as biological and physical deterioration elements. The quality of a paper support must be very high if the paper is going to be at all useful in a photographic process. Chemically, it must be pure and not react in any way with the light-sensitive chemicals applied to the paper. Physically, it must support the image through the fabrication steps and insure that the image layer does not detach during processing. With these prerequisites the integrity and character of the paper support used included good stability.

Paper Supports

Paper supports comprise the largest proportion of most photographic collections. Our understanding of paper's sensitivities to chemical deterioration has been

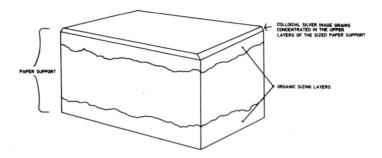

Fig. 3.5 Salted Silver Print, no discrete layering.

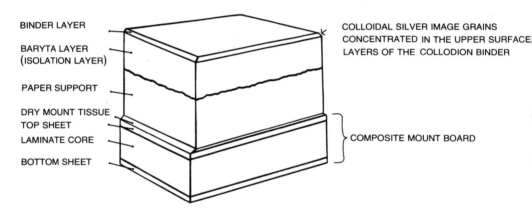

Fig. 3.6 Collodio-chloride Silver Print. Numerous, mixed layers including a secondary support.

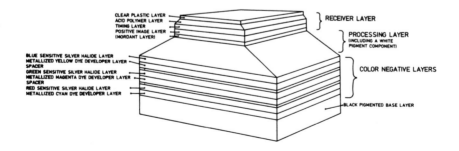

Fig. 3.7 Polaroid SX-70 Print. Very complex laminate structure.

enhanced by the research work done by paper conservators and scientists working to solve paper conservation problems. This work, and the results, have application to our problems as well, although some solutions may not be applicable, particularly buffering techniques.

The quality of photographic base paper for use as a support for the light-sensitive image forming compounds began as a quality paper made of "rag" stock. This was a very clean and well refined paper with excellent permanence and durability. The most important property was its inertness, its lack of reactivity with the coated light-sensitive materials. Machine-made papers were established in the 1850s as the demand for quality papers for use in photographic applications continued to grow. The use of wood-pulp papers is a relatively recent development, begun in North America by the Eastman Co. in the 1920s.

Wood-pulp papers are chemically reactive unless carefully and extensively treated during production, and the strength of these types of paper tends to be reduced because of this. The evolution of various additive fabrication processes for these types of papers has resulted in papers with good wet-strength properties, papers that are also inert.

The deterioration most commonly observed with paper supports will involve embrittlement due to acid migration from external sources, yellowing from residual fabrication chemicals, and physical damage due to tears and abrasion. Two examples of the acid migration problem include contact prints stored with the nitrate negatives they were made from and acid migration from poor quality, highly lignified mount boards onto which prints have been mounted. The effect of residual fabrication chemicals is a bleaching of the silver image due to thiosulfate or a yellowing of the paper base due to residual iron sensitizer in an iron process. Tears and losses are also associated with the acid embrittlement of a paper support. A mount board which has become brittle and breaks may take a piece of the print which is still in good chemical and physical condition.

The increase in the acid concentration in paper over time is a natural form of chemical deterioration. This acid hydrolysis is accelerated by many factors including the quality and type of fiber employed in the manufacture of the paper, the residual processing chemicals within the paper, and the environmental conditions under which the photographs have been stored or displayed.

The particular photograph may also have inherent in it some fabrication component that might contribute to the generation of acid hydrolysis by-products. The cyanotype and platinotype as well as palladium prints are fixed and stabilized with dilute solutions of hydrochloric acid. The use of an acid bath contributes to

the degradation of the paper support even in situations where an extensive, post-fixing wash bath is used to remove the residual acid.

The contemporary papers referred to as RC or resin coated are made up of a paper core with a plastic, polyethylene, coated on both sides of the paper. This allows shorter processing times, particularly in washing, and a shorter overall production time with a reduction in water consumption. The stability and deterioration of such photographs is still being improved and their long-term stability can only be approximated.

Plastic Supports

The plastic supports provide a problem in both chemical and physical deterioration. The first plastic base utilized cellulose nitrate, which deteriorates to form nitric oxides, which in turn form nitric acid. The chemical attack includes silver fading and gelatin dissolutions. The plastic becomes brittle and breaks and paper contacting the plastic disintegrates. The early cellulose acetates, while more stable chemically, still shrunk and deformed forming channels in the negative between the emulsion and the plastic support (Fig. 3.8). Only with the introduction of the triacetate and polyester supports do we acquire a stable plastic support.

Fig. 3.8 The loss of plasticizer in the early diacetate film base products has now resulted in the shrinkage of the base and the formation of canals between the support and gelatin binder.

The evolution of the plastics used as photographic supports began with cellulose nitrate. The demand for an alternative product was based on the fact that the cellulose nitrate was a flammable material with an associated fire hazard. The base was also chemically destructive to itself and any of the silver images in the collection with which it was housed. The length of its use as a film base, however, was extensive, primarily because of the difficulty in finding an alternative with comparable working properties.

The decomposition of cellulose nitrate evolves acidic and gaseous compounds, particularly nitrogen oxides and peroxides. These gases combine with water and water moisture present in the gelatin to form nitric acid. This is a strong acid resulting in very low pH values and the embrittlement of cellulosic supports and organic materials in the collection will occur, as will chemical attack on silver images and silver artifacts in the same collection (see Figure 3.3).

The evolution of plastics replacing cellulose nitrate include diacetate, which tends to deteriorate by virtue of a loss of plasticizer from the base. This blistering and separation takes place between the base and binder layers. The difficulty of copying these images after the blistering has taken place puts them in a high-priority group for treatment, before the blistering occurs.

The mixed esters appeared next in the manufacturing evolution of plastic-based supports followed by triacetate and polyester. The triacetate does not suffer from a loss of plasticizer and has a good stability. The most recent and most stable plastic base with the greatest dimensional stability is the polyester base.

Glass Supports

Glass supports are chemically stable but subject to breakage and cracking because of their brittle nature. Glass also has very little sensitivity to environmental changes. The problem this generates is that if the emulsion is gelatin it can become stressed in fluctuating or cycling environments, resulting in torn gelatin binders.

Deterioration of glass-supported artifacts is primarily associated with physical problems stemming from the brittleness of the glass itself. The most common example of a glass problem is associated with cracked or broken glass plates. Blistered emulsion layers, due to cycling environmental conditions, represent the next most common glass deterioration problem (see Figure 3.2).

The cover glasses used in daguerreotype and ambrotype cases have recently been detailed by research studies and the deterioration in this case is associated with exfoliation of materials from the deteriorating glass, which in turn reacts

with the image components of the photograph, resulting in corrosion by-products that attack the image.

Metal Supports

Metal supports used in photographic processes had two historical examples, silver on copper and silver on black-lacquered iron. The silver on copper is exemplified by the daguerreotype, which is subject to silver tarnishing. The black-lacquered iron plate, coated with a collodion binder, was the tintype or ferrotype. Such photographs are easily bent and the lacquer coating cracks, allowing corrosion to take place on the iron plate. Rust can often be seen breaking through the image layer and causing exfoliation of the image (Fig. 3.9).

The use of metal supports tends to be limited to daguerreotypes and tintypes. In general, corrosion by-products resulting from high relative humidities are the problem. The large areas of exposed silver on the daguerreotype plate also react with sulfur-containing gases to tarnish the plate and obscure the image. Tintypes have an iron core that can rust when exposed by physical damages that crack the black-lacquer layer.

Fig. 3.9 The iron support of the Tintype will rust through and lift the image in areas where the black lacquer coating layer has been damaged. These two tintypes show the front and back surfaces of a tintype and the black lacquer layer is clearly visible on the back.

Deterioration of Binders

The binders used in photography include albumen, gelatin, collodion, gum arabic, and starch. The binder holds the image or image particles in a restricted space to insure a high concentration of image forming components. Initially the paper support was sized with starch or gelatin to minimize the diffusion of the light-sensitive compounds that formed the image from sinking into the support. This process of isolating the image layer continued with the use of the double coated albumen layer in the albumen print and has culminated with today's papers which have a white pigmented layer between the image binder and the paper support.

Gelatin Binders

The gelatin used as the binder in a gelatin emulsion is a refined extract derived from animal hides. The gelatin binder in a gelatin emulsion, because of its hygroscopic character absorbs moisture and accelerates chemical deterioration reactions which are water based. In some situations the gelatin also reduces deterioration reactions, which involve gaseous contact because the image particles are surrounded by the gelatin rather than being exposed at a surface. Gelatin emulsions are also subject to biological deterioration and mold attack, particularly at relative humidities above 65 percent. Relative humidities less than 65 percent may still involve insect attack. Physical problems with gelatin include scratching and abrasion, blistering when subjected to cycling environments, and melting and distortion when exposed to high temperatures.

Gelatin binders are a food source for insects and micro-organisms and as such may display attack by mold and fungus as well as insects and rodents. Conditions of high relative humidity promote the attack by fungi and mold, the resulting deterioration includes a loss of the image, the conversion of the gelatin into a water-soluble intermediate material, and staining and discoloration of the support layer.

Attack by insects and rodents results in the direct loss of the image layer and an associated staining and discoloration due to feces and other by-products which attack and discolor the binder and support. The high acid content of these by-products also results in embrittlement.

The gelatin binders are generally good when physical deterioration is limited to light abrasion. The gelatin has a slight flexibility and absorbency of deformation by which small dirt and grit particles pass without scratching. Larger particles and greater weights will result in scratches.

The chemical stability of gelatin is very good, but residual processing chemicals

coupled with the ability of gelatin to absorb several times its own weight in water moisture can result in accelerated deterioration. Chemical deterioration by moisture bound in the gelatin layer can significantly increase the rate of deterioration of an image. In general, gelatin binders deteriorate to a more brittle state.

Starch Binders

Starch used as a binder, in a sizing application, will also be subject to biological deterioration analogous to gelatin. The starch is not subject to the same type of dimensional problems in cycling situations and, because of its thin layer of application, it is not as sensitive hygroscopically.

Albumen Binders

Albumen as a binder material is neither a source of food for biological agents nor very hygroscopic. The fabrication steps in the albumen process include the denaturing of the protein and this step reduces its degree of interaction with most of the environmental deterioration agents. One problem associated with albumen binders, which affects the silver image of an albumen print, is that some of the silver sensitizer is bound molecularly to the albumen during the sensitization step. This bound silver cannot be removed in the fixing bath, and the result is a continued yellowing of the print due to silver sulfide formation—most noticeable in the nonimage highlight areas.

Recent research has identified the yellowing of the highlight areas of albumen prints to include also the result of a reaction between the sugars in the albumen and the albumen protein itself. This problem was compounded by the manufacturers of albumen paper, who fermented the albumen prior to coating and thus increased the amount of the sugars present in the albumen. The general deterioration of the albumen binder in an albumen print includes the discoloration of the highlights, generally a darker yellow color in the nonimage areas and a fading or loss of density in the shadows. This fading in the shadows is also associated with a color change from a purple black to a yellow brown.

The albumen binder is a denatured protein, and the fact that the protein has been denatured and is no longer water soluble, results in a strong, durable, and less reactive binder than gelatin. Since the albumen is not a food source, biodeterioration is minimal. The denatured form also reduces the hygroscopsicity that is present in gelatin, thus reducing the moisture content and hydrolysis-related deterioration.

The albumen layer does, however, show a mechanical or physical deformation

Fig. 3.10 The albumen binder layer will show a surface texture made up of fissures and cracks. These cracks are shown here at approximately 80X magnification.

particularly in mounted examples. The prints tend to show a network of fissures through the binder layer over the entire print. These are stress related due to the mounting methods used and the changes which take place as the print shrinks during drying (Figure 3.10).

The deterioration which is most common with albumen prints is the discoloration of the print. The highlights tend to yellow and darken while the shadows tend to lighten and fade. These two reactions are different deterioration processes. The highlight staining is related to the alteration of the denatured albumen to a colored body. The fading, or loss of density in the shadows, is due to the conversion of the collodial silver image to a silver compound with reduced covering power.

Collodion Binders

Collodion is a synthetic produced by the reaction of cotton (pure cellulose) with nitric acid. This solution is then dissolved in an ether and alcohol mixture and allowed to evaporate. The plastic film or sheet left after evaporation of the solvents is cellulose nitrate. The use of collodion as a binder differs from the gelatin and albumen examples. The collodion layer is not moisture sensitive and humidity conditions and biological deterioration are relatively lesser considerations.

High temperatures and dry environments can lead to an embrittlement and loss of plasticizers followed by crazing and exfoliation of the collodion layer. Collodion is also very sensitive to physical damage, particularly scratching. Collodion plates were usually varnished to minimize scratching and chemical interaction with the printing papers. The identification of collodion binders is usually apparent

when examining for scratches. The presence on the collodion binder of small, fine scratches in the binder layer suggests a collodion binder.

The chemical deterioration of the image in a collodion binder tends to be less than that of a gelatin print of comparable fabrication. The collodio-chloride print was also popular as a double-toned print process and as such has an increased chemical stability derived from the use of two different toning salts.

Collodion on glass displays deterioration, including the blistering and lifting from the glass support analogous to the gelatin example but generally not as severe or extensive. In this situation, the fault is usually associated with a loss of plasticizer and increased brittleness rather than cycling environmental conditions. The same relationship is observed with cellulose nitrate base deterioration when loss of plasticizer occurs, although there are other deteriorative processes also taking place that contribute to embrittlement.

Intermediate Layers

The intermediate layers in most photographic artifacts are limited to the baryta layer. This is the intermediate layer between the image-carrying binder layer and the paper support. It is a layer of barium sulfate pigment in gelatin. The barium sulfate pigment, now replaced by titanium dioxide, is used to create a brighter background to view the image on. It is chemically inert and is built up by a series of coating applications onto the paper support. The binder layer is then applied on top of this layer. The baryta layer can also be textured to provide a surface texture for the image and binder.

The baryta layer also provides a partial chemical barrier from the migration of deterioration products and residual chemicals from the paper support to the image in the binder. This is a restraining process and also aids in stabilizing the photographic print to a limited degree.

Stability Interrelationships

The stability of the various structural components that make up the photograph may resolve how it will respond to the deterioration. The structures of some photographs have become quite complex and now include more than just a support, an image, and an image layer (binder) (see Figure 3.7).

Each of these may have optical, chemical, or physical sensitivities which could, in time, lead to instability. An excellent example of this is cellulose nitrate (often referred to as nitrates), used as the first flexible transparent support for a photographic system. We know that its own deterioration results in the eventual

destruction of the image which it supports. The presence of deteriorated nitrates in a general storage area will cause the accelerated degradation of other images as well, making nitrates the most damaging material to be found in a collection.

There is also the problem of the interrelationship between different components in contact with each other within the entire artifact cross-section: the adhesion between the subbing layer and the binder on one hand, and the subbing layer and the support on the other hand. Blistering of the gelatin binder from the shrinking diacetate base is an excellent example of the failure of the subbing layer adhesion (See Fig. 3.8). The lifting and blistering of the gelatin binder from the baryta layer is an example of the failure of these internal adhesion bonds on a gelatin silver print.

This entire relationship is then extended beyond the photograph itself when considering the finishing and flush mounting of a print. This mounting onto a secondary support for presentation or display introduces a new restraining and stressing component—the mount. The traditional mounting technique involves the application of a heat-melting adhesive applied to the back of the photographic print and to the front of the mount. The stresses introduced during the mounting process and in subsequent environments can lead to excessive stresses on the print and mount, resulting in tears and mechanical damage.

The mounting of paper prints into photographic albums and onto card mounts, using an animal glue at the four corners of the photograph, also results in stresses that tear and rip the print, damaging the image. This configuration in environments of cycling relative humidities and temperatures results in the greatest amounts of physical damage.

Deterioration of Silver Images

Silver-based images have been the foundation of photography since its beginnings as a stable image-forming process. The fabrication processes made use of a silver halide salt, usually silver chloride or silver iodide, and later silver bromide or mixtures of the above. In processes in which the image printed out, the image was visible after an extended exposure to bright sunlight; the silver was precipitated in the form of finely divided colloidal silver. The physical form of this colloidal image is a fine, spherical-shaped grain of pure silver. The shadow or Dmax values are represented by a high density or packing of silver grains while the highlights or Dmin areas have few if any grains.

The deterioration chemistry and the rate of the deterioration of silver images are related to the surface area available for reaction. The spherical shape of the

colloidal silver grain found in the print-out processes provides the maximum available surface area for reaction, especially when compared to the filamentary structure of a developed out print process. With this relationship in mind, it is clear that the areas of minimal silver grain concentration or image density would show the effects of deterioration first since there is less material available and hence the reaction would be exhausted earlier than an area of greater density. Fading of a silver image involves the conversion of the metallic silver to silver sulphide. The optical covering power of this new compound is less than the original and results in a loss of density or fading. The chemistry of the process also contributes to this loss of density since the conversion from the silver to silver sulphide requires two atoms of silver to every atom of sulfur.

Early in its evolution, the silver print-out process underwent an aesthetic change that also assisted in increasing its stability. The silver image, immediately after exposure and fixing, had an unattractive color and also displayed a rapid deterioration reaction. The color modification was achieved using gold salts as a toning bath applied immediately after printing but prior to fixing. The result was both an image color change due to gold deposition onto the silver grains as well as an increase in image stability because the silver was now coated with a layer of a more inert chemical, reducing the silver surface area available for reaction. The color of the image changed, depending on the gold toner formulation, particularly the pH of the bath. Platinum toners as well as a gold toner followed by a platinum toning bath were also used. This last sequence, using two inert toning chemicals, appears to have provided the most stable images for the silver print-out images.

Silver, although considered a noble metal, does have a chemical sensitivity, particularly to oxidizing gases and to sulfur compounds. This reaction to sulfur has already been described as a conversion of metallic image silver to silver sulphide. The sources of sulfur in the silver imaging systems can be found in the actual fabrication process. The silver halide solvent used to dissolve out the unexposed light-sensitive compound in the light-sensitive layer is sodium thiosulfate. The thiosulfate ion contains sulfur, which on deterioration forms dithionates. The removal of the thiosulphate is imperative to the long-term stability of the fabricated silver image. Compounding this problem is the fact that the thiosulfate is naturally bound to the paper fibers and cannot be washed out or removed unless a chemical treatment step such as a hypo-clearing agent is incorporated into the treatment sequence.

Other sources of sulfur include atmospheric pollutants, particularly sulfur diox-

ide and residual sulfur in products used to protect and house the photograph. The quality specifications for paper and cardboard materials must be low in residual sulfur or chemical deterioration will occur. Excellent examples of this problem can often be observed when a newly acquired collection is examined. Many of the photographic negatives will have been stored in the film or plate boxes in which they were purchased. These boxes are made of poor-quality paper materials; this fact was secondary to the use of this container for storing the unexposed materials because the light-sensitive materials were isolated from them by a barrier of quality packaging materials.

Another chemical interaction detrimental to the stability of a silver image is the presence of nitrogen dioxides and peroxides. Silver is soluble in nitric acid and the formation of nitric acid can occur when nitrogen dioxide pollutants combine with water or water moisture. The silver image will be dissolved and the support and binders will deteriorate both chemically and physically. The source of these nitrogen compounds can also occur from within the collection, particularly if cellulose nitrate based materials are present.

Peroxides will also contribute to the oxidation of the silver image, the most common source for these being oil-based paints. Areas of storage, display, and patron access should not be painted with oil-based paints but rather with a latex paint. If used, oil-based paints will require the removal of all silver-based images, as well as other artifacts, for a period of time to allow the complete curing of the paint and the removal of all of the paint fumes. The use of latex paint should also require that the artifacts are removed prior to painting and the paint allowed to dry prior to reoccupying the space and returning the photographs.

Chemical Processes and Silver Image Deterioration

The deterioration processes associated with silver images and described in chemical terms can be summarized as an oxidation reaction followed by a reduction reaction step. Oxidation of the metallic silver to an ionic form followed by reduction back to a metal state is known as mirroring, if the ion has migrated to an exposed surface and is reduced there, forming a mirrorlike layer. Oxidation followed by reduction with reactive sulfur compounds is known as sulfiding when subjected to residual sulfur compounds (Figure 3.11).

The manner in which these two deterioration processes can occur varies. The oxidative reaction may be based on a reactive gas present in the storage areas including hydrogen sulfide, sulfur dioxide, oxygen, ozone, nitrogen oxides, peroxides, or ammonia. The oxidative reaction can also occur from residual thio-

Fig. 3.11a This mirroring feature is most common with gelatin silver prints and gelatin silver emulsion processes. The surface sheen is most commonly found in the outer edge areas of the artifact and in the maximum density areas of the image.

Fig. 3.11B This high contrast print is the result of the conversion of the upper highlight tones into a yellowish stain. The image contrast increases with this loss of highlight detail.

sulfates present from the processing bath or from sulfur compounds present in other materials that contact the silver image. Subsequent reactions with any of the materials listed above then result in the formation of a new silver compound within the photograph.

Silver Deterioration Examples

Daguerreotype

The copper and silver metal matrix that makes up the daguerreotype demonstrates the type of deterioration most common with silver photographs. The large surface area of nonimage metallic silver that supports the image tarnishes to a blue-black color due to the formation of silver sulfide. The color of this tarnish begins as a yellow-brown similar to the sulfide found on colloidal silver images, but because the layer thickness is so much greater the color is a darker blue-black (see Figure 3.1).

The tarnishing of the silver plate also tends to follow the exposed interface of the brass metal matt that contacts the plate in the common-cased format. Plates that have not had a brass matt configuration do not show this type of deterioration. The cased photograph format also included a cover glass and outer brass retainer, which was sealed together with paper tape to restrict the entry of undesirable components. The glass used in this construction tends to weep and drop debris on the plate surface, causing local corrosion to take place.

Calotype Negatives and Positives

The deterioration of the calotype negative differs significantly from that of the positive. The negative image is a developed-out image resulting from a short exposure in the camera to form a latent image which is subsequently developed chemically. The image silver structure is filamentary in nature and much more stable chemically. The positive image, however, is a printed-out image, colloidal in form, and more susceptible to chemical deterioration than the negative.

The positive prints tend to show edge fading and deterioration rather than changes within the body of the print. The exception to this is a local staining due to residual chemicals that have concentrated in an area within the print. The reason for the edge deterioration occurring along the perimeter is primarily because access to the print by gaseous components is greatest along the exposed edge. Prints housed in albums confirm this. The spine edge, which has least exposure to the gaseous pollutants, also shows the least chemical change. The fore edge,

however, shows the greatest amount of change because it tends to be the most exposed edge. The head or top follows and the tail or bottom, which is partially protected by the shelf, shows less change than the head or top edge.

Silver Emulsion Prints

The silver emulsion prints include both print out and develop out processes. The print out processes are collodio-chloride and gelatino-chloride. The silver image in an emulsion process is protected to some degree from the deteriorative effects of gaseous pollutants because of a restricted access provided by the binder and the fact that the image lies within the binder layer. The gases must diffuse through the binder to reach the silver image. The gelatin binder does not present as great a barrier to the pollutants as the collodion binder, which is less sensitive and responsive to changes in water moisture. The collodio-chloride prints were also regularly double toned, using both gold and platinum salts. The resultant images were inherently more stable. Both of these print out processes are colloidal silver and are less stable than the develop out emulsion process. One last observation is that although the chemical stability of the collodio-chloride exceeds the gelatino-chloride the gelatin binder has better physical properties and will not scratch and abrade as easily.

The develop-out silver emulsion process is in popular use today and it has the best stability of the various silver emulsion processes. The binder of gelatin does allow the diffusion of gaseous materials, but the image is developed and filamentary in form and thus more stable than the colloidal print out gelatino-chloride. The silver gelatin print is subject to silvering or mirror formation on its surface in shadow areas and along the outer perimeter edges. This silvery reflective surface is most prominent in the shadow or Dmax areas because of the high concentration of silver in these areas. The mirror forms through the conversion and migration of image silver within the gelatin emulsion to the surface of the gelatin. The rate of this chemical reaction is accelerated by storage environments with high relative humidity.

Deterioration of Nonsilver Images

Nonsilver images can be divided into two groups, metallic salt processes and colloid relief processes. The most significant metal salt processes involve the use of an iron sensitizer. The iron compound provides the image-forming process and can in turn be used to further reduce another metallic salt to form the actual

image. The platinotype is an example of this type of associated reduction. The iron-sensitive salt is exposed and reduced followed by instantaneous development in a bath containing the platinum salt. The platinum salt could also be mixed with the sensitizer and although weakly light sensitive, it does not participate in the light-sensitive reaction of the process. The platinum process gained popularity because it was a permanent process and had excellent chemical stability; it does not fade or lose density with time.

There is a form of deterioration associated with this process and it involves the yellowing of the paper base, embrittlement of the paper base due to acid hydrolysis and physical damage associated with the paper support materials. The transfer of a positive image impression to an adjacent sheet of paper is an indication of the presence of platinum. This reaction is an indication of the reactive, catalytic nature of platinum, which is also very stable chemically.

Cyanotype

The cyanotype is an iron process that utilizes direct reduction of the iron light-sensitive compounds to form an image. The process has excellent chemical stability except for an alkaline sensitivity. Mild alkali solutions and compounds will cause the image to fade and discolor. Strong alkali solutions will bleach the image irreversibly to a light yellow color. The paper support is also subject to the same chemical deterioration as the platinum print process.

Kallitype

The kallitype is a process that uses an iron sensitizer to reduce a silver image. The image quality is similar to a silver print and the process has the same silver deteriorative problems as well as those associated with the iron processes. Careful processing and a protective toning bath are imperative if this image is to have any stability at all.

Platinotype

The platinotype employs an iron sensitizer and reduces a platinum image by association with the exposed iron sensitizer salt. The image is quite stable chemically but it can result in the catalytic deterioration of the paper base which supports it. The most common associated deterioration effect is the appearance of a transferred or reflection image on the adjacent paper sheet. This is caused by the contact and deterioration of the contacting paper by the platinum image.

Images in Colloid Processes

The dichromated colloid processes were also associated with a desire to obtain a permanent image process. The components present in the fabrication process are a colloid binder for an image made up of a pigment exposed in a system that uses a dichromated, light-sensitive salt. The deterioration of these images is minimal because the stability of the pigments is generally high. The deterioration of the colloid is related to the problems associated with storage environments, particularly very low relative humidity conditions, which embrittle and crack the thick, water-sensitive colloid.

The ability of any given dichromated-colloid process to resist image deterioration is based on the light stability and overall chemical resistance of the image-forming components. The use of inorganic pigments in the colloid binder resulted in high image stability and permanence. The use of inferior materials resulted in fading and image loss.

The use of dyes rather than pigments in some of the three-color colloid processes such as carbro results in image stability problems. In situations like this the photochemical reaction of the dyes with light results in the fading of the image and a loss in density, due to a chemical breakdown of the image-forming dye.

The use of inorganic pigments in colloid processes, like the carbon transfer process, even when using a single-color pigment, can result in light damage if the pigment is photosensitive. The use of a mixture of chrome yellow and prussian blue to provide a color substitute for the more permanent chrome green is an example that was commercially manufactured.

Deterioration of Color Dye Images

The deterioration reactions associated with the loss of dye color in contemporary color photographic materials are related primarily to photochemical or light-initated oxidation processes and secondarily to chemical oxidation processes. The stability of various color products is described by researchers in terms of their dark-keeping and light-keeping properties.

The problems associated with color dye systems, regardless of the method in which they are fabricated, have little or no treatment recourse. The materials that comprise the image as organic dye systems will show deterioration rates that are considerably faster than conventional processes such as the silver gelatin system. The preservation solutions appear to be limited in terms of controlling the internal instabilities of the dyes by controlling the external or environmental conditions.

The stability of the dyes can be increased significantly by storage in low-temperature, dry relative humidity environments.

The older color print processes utilized black and white silver systems in additive filter combinations to produce stable color images composed of color pigments instead of color dyes. The evolution to color dye systems has resulted in poorer stability. The stabilities of contemporary color products is discussed in terms of either dark-keeping or light-keeping properties. Dark keeping implies storage with little or no active viewing while light keeping implies active viewing under light projection or light reflection conditions.

The following table is extracted from information provided by Henry Wilhelm over a period of time and from presentations, publications, or conferences.

Dark Stability	**Light Stability**
Ultra Stable	**Ultra Stable**
Cibachrome	Polaroid Polacolor
Dye Transfer	
Fuji Dyecolor	
Polaroid Polacolor	

New Orleans *PMG* 1987

Dark Stability	
Kodak Dye Transfer	(>50 years)
Kodak Kodachrome	(>50 years)
Kodak Ektachrome (E-6)	(20-50 years)
Kodak Ektachrome (E-4)	(10-20 years)
Kodak Ektacolor	(6-10 years)
Kodak Vericolor	(<6 years)
Kodal Ektachrome (E-3)	(<6 years)
Eastman Color Negative	(<6 years)

PHOTO COMMUNIQUE, 3:1, 1981

Fig. 3.12 This albumen print, a copy of an art piece, was hand-colored and matted. The image has faded away leaving only the color and a ghost of an image. The poor washing during processing left high concentrations of thiosulfate in this print and the decomposition products of this residual chemical have attacked and converted the image.

The Fabrication Process

Residual Processing Chemicals

The image fabrication process and the chemicals used to stabilize the image can play a major role in the inherent deterioration that an artifact displays over time. It is now apparent that residual processing chemicals from the fabrication step —particularly for silver-based processes—may in time attack the silver image, image binder layer, or, support. For silver images, residual thiosulfates, and silver thiosulfate complexes, may chemically alter the silver image to silver sulphide.

In early fine-grained silver print processes, the presence of residual processing chemicals, particularly sodium thiosulfate or hypo, resulted in the conversion of image silver to silver sulfide. In the albumen process, and to a lesser degree than in the other silver-based processes, residual thiosulfate also caused highlight stain and discoloration. The change in both image color as well as a loss of image density, particularly noticeable in the highlights, is the most common deterioration we observe on these early silver materials (Figure 3.12).

In the gelatin emulsion, silver develop-out papers, the relationship between the dissolution of silver by sodium thiosulfate and the ability to remove the silver-thiosulfate complex that forms as the bath is exhausted was established in the

1950s. It is apparent from this work that the water solubility of the silver-thio-sulfate complexes in the fixer bath rapidly drops as the bath is exhausted. The only way of removing these complexes from the print is a second, fresh fixer bath. This is the basis for the two-bath archival processing sequence.

The removal of thiosulfate from film and print materials was investigated by several researchers during this time and the use of a hypo clearing bath was also added to the archival processing sequence. The inability to remove all of the hypo from the paper print indicated that most historic silver-based prints could be expected to show some deterioration due to residual thiosulfate left in the paper's fibers.

Residual processing chemicals have implications in other processes as well. The use of an iron sensitizer in the platinum print process and in the cyanotype process could lead to a yellowing and discoloration of the paper base if the residual fixing solution and the unused iron were not efficiently removed during washing. The catalytic degradation of the paper cellulose by the iron is minimized in the platinum process by fixing with a diluted hydrochloric acid solution. The inefficient removal of this acid from the paper base will result in cellulose degradation and acid hydrolysis attack resulting in a brittle paper support.

Inadequate Product Design

The inadequacies of the manufactured photographic product or the promotion of a process that is inherently flawed can often be the cause of inherent deterioration. The best example of this type of manufactured product failure would be the continued use of cellulose nitrate base supports after the shortcomings of the materials had been determined by the industry.

Cellulose nitrate will be discussed numerous times within the content of this work, because of the impact the material has on the images preserved upon it as well as the materials it is stored with. The deteriorative problems of cellulose nitrate were evident shortly after its use began in photography and cinematography, but the evolution of safety film did not occur in a timely fashion. The new safety-film base was introduced in different formats during the late 1920s, 1930s and 1940s. The replacement of 35mm cellulose nitrate motion picture stock did not occur until 1951.

The self-destructive nature of this support base has resulted in the loss of priceless images recorded photographically during the first half of this century. The replacement product, called safety film, also suffered from a design problem. The diacetate film support, designed to replace the nitrate, still made use of a

nitrate subbing layer and lost plasticizer. The loss of plasticizer manifests itself in a shrinkage of the base and the formation of canals as the emulsion blisters up and away from the plastic base. This is a major problem for archive collections, because it is impossible to provide decent copy images from photographs suffering this type of deterioration.

The use of the various dye systems in contemporary color products might also qualify as poor product design. In fact the introduction of a new color negative system by a major photographic manufacturer a number of years ago resulted in a dye system so fugitive that many professionals could not print from their negatives just a few years later. The problem of a dye system that was new and not very stable resulted in the design of a new product with better stability. The recommendation for materials shot on the poor-stability materials was storage in a low-temperature environment and special freezer bags were produced for professional photographers to use. The bags now have an application for the storage of all photographic materials, which are deteriorating rapidly and are discussed further on page 121.

Secondary Supports

The use of a poor-quality paperboard as a secondary support is yet another example of inherent vice, this time by association. The presence of lignin and organic acids from partially processed wood-fiber paper board as well as residuals such as chlorine or thiosulfate in the board can contribute to the deterioration of the artifact. The intimate association of this secondary support to the artifact results in the direct migration of the undesirable materials into the artifact.

The use of poor-quality adhesives, or hygroscopic adhesives, exacerbates the situation even further. Mounting adhesives like rubber cement or contact cements results in extensive damage to the image, particularly silver images, in just a short period of time. The adhesive problem is also evident in the form of faded lines through the images of photographs, both color and black and white, placed into commercial albums. The application of the adhesive to the page in thin horizontal lines with the plastic cover sheet in place results in a fading of the image in the contact areas. Prepasted albums are not safe for photographic materials.

Deterioration Associated with Embellishments

The association of nonphotographic materials on or in a photograph, to embellish the image or presentation, often results in damage to the photograph. The use of

a bronze-line border on albumen and gelatin *cabinets* and *cartes-de-visite* prints has resulted in a mottled or spotted deterioration of the silver image in the areas where the bronze powder has shed and fallen onto the photograph's surface (Figure 3.13).

The use of oils and watercolors on the surface of a print can also result in deterioration. The presence of sulfur compounds, as a part of the applied color, can result in staining and discoloration. The reaction of some pigments with the image silver may also result in the formation of mirroring in the denser silver areas. The oils and other elements in the artist's materials might also cause stains and reactions with the image.

Fig. 3.13 The presence of bronze powder borders on mounted albumen photographs has resulted in the formation of numerous small spots on the image. The image silver has been attacked and altered.

Cleaning and Stabilizing Photographs

CLEANING

Cleaning is designed to remove surface dirt and greasy residues from a photograph's surfaces. The procedures outlined here are surface treatments. In one technique Kodak Film Cleaner is applied with a Q-Tip, or cotton-batting applicator to the binder or image-carrying layer. In the other technique, eraser bits are applied to paper supports on the nonimage side and to paper mounts and secondary supports using a light rubbing motion. The applications of immersion techniques or stain removal techniques will not be discussed in this section because they fall into the category of treatments that should be performed by conservators or trained technicians.

The general cleaning procedure that is recommended for photographs includes the following steps:

- Remove the photograph from its envelope or enclosure and place it, emulsion side up, onto a clean auxiliary support.
- Dust the binder or emulsion surface with a soft brush; repeat the dusting step to include the secondary support; use the auxiliary support to turn the artifact over, and repeat on the nonemulsion side or the back of the secondary support.
- Repeat the entire sequence a second time.
- Clean the support and the binder, then by turns, respectively with the appropriate methods described below, either the film cleaner or the eraser bits.
- The photograph should not be immersed into a liquid at any time. Never use benzene or ammonia as a substitute for the film cleaner. Water and alcohol should be used only for spot tests and only if absolutely necessary.

This technique is described in the next section. It is imperative that you complete a spot test of any liquid before applying it to a binder or image.

Spot Testing Photographs

Spot tests are utilized whenever a liquid solution or solvent is to be applied to a photograph's surface. The purpose of this is to insure that the photograph and particularly the binder will not react to the applied solution. The compatibility of the solution and photograph is determined by placing a small, controlled amount of the liquid on to an edge of the photograph and watching for a change in the physical properties of the photograph in the applied area.

- The use of a micro-swab, which has been dipped into the test solution and then touched to the edge of the bottle, provides control over the amount of liquid applied to the photograph.
- The application of the liquid is made to the emulsion side. A small drop of the solvent is placed onto a nonimage edge area (Figure 4.1) (the border edge is an ideal location), which is observed for a change in character.
- The use of an excessive amount of the liquid could result in its spreading well into the image. If it is also reactive it could result in the disfigurement of the artifact.
- The observation of the area on which the drop has been placed should be continued for a few minutes or until the beginning of a change in the surface characteristics of the binder layer are observed. The surplus solvent must be removed immediately by blotting the area and insuring that the solution is removed from the surface as quickly as possible. Do not apply pressure or rub the surface during the blotting operation (Figure 4.2). The surface of the binder may have become swollen and mechanically sensitive.
- The surface of the spot test should be observed after the application of the test, using a raking light, to complete the observation process (Figure 4.3). The results of some tests will include changes in the surface topography that include swelling of the binder or changes in the surface texture. The presence of a small area that has been partially dissolved will be apparent by raking light as a small crater or cavity with an increased surface texture.
- The observation of the blotter paper after blotting and again after the solvent in the blotter has dried can also provide information on the presence of a soluble binder or image components' presence within the artifact.
- Restrict the application of spot tests as much as possible. The damage caused

Fig. 4.1 The application of a drop to an edge area must be controlled to minimize the amount of damage which could result from a positive test.

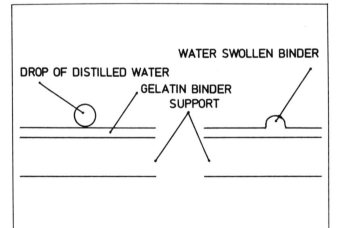

Fig. 4.2 The area tested must be blotted after the test period is complete or if an alteration of the test area is apparent.

WATER SWOLLEN BINDER

DROP OF DISTILLED WATER

GELATIN BINDER
SUPPORT

Fig. 4.3 The swelling of a gelatin binder after spot testing with distilled water can be illustrated by a hill or mound in the application area. This area should be viewed in raking light.

to photographs by the indiscriminate application of treatments and spot tests can lead to irreversible damage. The use of Kodak Film Cleaner has been found to be safe with most emulsion based binder photographs, but the application can lead to surprises from time to time because the photographer deviated from the norm and applied a varnish layer or waxed the print to provide a luster for the image.
- The application of a spot test before using a liquid solution is a sound pretreatment step that should be used by anyone cleaning photographs.

Paper Supports

Cleaning the Paper Support
- This procedure is generally applicable to photographic paper supports. It should not be applied to images that are or have become friable or sensitive to mechanical damage and abrasion. The image side is face down during this operation, and therefore abrasive damage can occur to delicate image layers during cleaning.
- Prior to cleaning the emulsion, the paper support will be cleaned by placing the item emulsion-side down onto a clean auxiliary support. Secure it with a padded weight to minimize any movement during cleaning.
- Apply eraser powder or Scum–X to the back of the print: move it about with a gentle circular motion, using only the bottom of your fingers (Figure 4.4). Work from the center outward to the edges, and work around any tears or losses in the paper support.
- Tears or raised edges must be carefully worked around in such a fashion so as not to catch the edges causing further damage.
- Prevent movement of the print during cleaning and minimize the amount of powder that crawls under the print to the emulsion side.
- Dust the powder off (use separate brushes to dust the photograph, and to dust off the eraser powder), and examine the paper surface (Figure 4.5). Reapply fresh powder and continue these applications until the powder no longer discolors during the cleaning operation.
- Dust well, and if necessary, use a soft vinyl type of eraser on any remaining stubborn scuff marks. Do not rub with excessive force because you can raise the paper fiber.
- Dust the print again, including the emulsion, thoroughly with a soft brush to remove any eraser powder residues.

Fig. 4.4 The use of a dry cleaning powder on the paper components of the photograph can reduce or remove some form of soil and dirt. These powders include abrasive materials and must be applied with care.

Fig. 4.5 The dust tends to spread over the photograph and dusting with the brush must be repeated until the photographic mount is clean. The brush requires regular vacuuming to remove the dust that builds up inside the hairs.

- Do not apply film cleaner to the paper support.
- Do not apply this technique to Photo Pastels, oil or bromoil prints, or to gum bichromate prints. Carbon and carbro prints can be cleaned but should be face down on a thick and absorbent blotter paper during the cleaning step.

NOTE: This method of cleaning the paper support can also be used to clean paper mounts to which photographs are adhered or mounted onto.

Cleaning the Emulsion

- The application of a solvent for cleaning is appropriate for prints with binders, particularly gelatin binders, but inappropriate for print processes that do not have binder layers. The following print processes should not have film cleaner applied to them: platinum and palladium prints, calotype negatives and positives, salted silver prints, cyanotypes, oil and bromoil prints and gum bichromate prints.
- After examining and cleaning the paper support, lightly dust the emulsion surface with a soft brush (a shaving or oriental brush), and place the print emulsion-side up on a clean auxiliary support. Weigh down the print, placing a clean card between the emulsion and weight.
- Apply a cotton ball or swab lightly dipped into Kodak Film Cleaner or trichloroethylene (remember to spot test before applying liquids) to the emulsion surface after touching it to the container's rim (Figure 4.6). These chemicals require a well-ventilated area; the solvent container should be capped between applications.
- The swab should be moved in a light, circular pattern. At the same time rotate the swab between the fingertips during this motion. Replace the swab once it becomes dirty.
- It is important to replace swabs regularly during cleaning, and to store discarded swabs in a resealable container, which should be emptied regularly into a solvent disposal can. Do not allow an excessive number of these swabs to accumulate in the work area.
- Continue to apply solvent swabs until the cleaning solution no longer streaks on the emulsion and the swab no longer picks up dirt and grease after the application.

NOTE: This technique should not be applied to albumen binders. The craquelure texture (cracked pattern) common on many deteriorated albumen binders may hold or trap material and attempts to remove these embedded materials may

Fig. 4.6 The swab with film cleaner should be replaced when dirty and redampened when dry. The solvents used in the film cleaner are designed to evaporate quickly. Watch out for dry swabs with dirt particles in them, which can scratch the binder layer.

lead to fixing the dirt in the cracks or lifting the binder. In many situations it may be necessary to restrict the cleaning of albumen binders to a thorough dusting with a soft brush.

Glass and Plastic Supports

Cleaning the Emulsion and Support

- The application of these techniques is appropriate to all photographs with glass and plastic supports. All of these will have a binder layer.
- After examining and dusting both sides of the photograph with a soft brush (remember to use separate brushes for dusting the photograph and dusting off the eraser powder), place it emulsion-side up on an auxiliary support.
- Then apply the cleaning solvent swabs to the emulsion surface, as was outlined in the cleaning of print emulsions (before applying a solution or liquid to an artifact, conduct a spot test).
- Dust the auxiliary support; turn the item over; apply solvent swabs to the nonemulsion side.
- Any material still adhering to the nonemulsion glass side after swabbing should be carefully removed mechanically by scraping with a scalpel. Remember, this is the glass side, not the emulsion side (Figure 4.7).

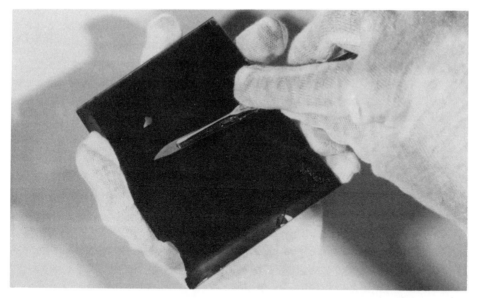

Fig. 4.7 The glass side of a glass plate can be scraped with a scalpel to remove material coating this surface. The presence of paper tapes as well as residual adhesives or greasy deposits can be removed this way.

Metal Supports

- The application of the cleaning methods to metal artifacts is limited because of the potential damage which could be caused during cleaning. In general, dusting is the limit of the cleaning which can be done by the nonprofessional.
- Dust both surfaces lightly with a soft brush, holding the photograph by the edges.
- Photographs contained in cases should not be disassembled for cleaning unless the cover glass shows extensive weeping or deterioration. See pg. 100 for detailed instructions.

Fungus Removal

- Fungus and mold growth on gelatin emulsions can be removed with the film cleaning solution. The areas where the fungus has been growing will be etched and pitted and this cannot be altered. Do not allow water to contact gelatin emulsions which have been subjected to fungal degradation, since the emulsion may have become water soluble.
- Fungus-infested areas can be detected during examination by the use of an ultraviolet light. The fungus growths fluoresce as bright blue-white spots and areas.

- Do not look at the light source. Wear protective glasses when using the ultraviolet light.

Brush Maintenance

- The dusting process described above uses two separate brushes, one to remove dirt and the other to remove eraser-powder residues. Both of these brushes will require regular cleaning to remove materials accumulated in the brush.

 1. Mix 5 to 10 mls. of a mild detergent (Fisher FL-70) in a 1000 mls. of water.
 2. Dip the brush into the solution and allow it to drain.
 3. Rub the bristles in a gentle, circular motion in the palm of your hand.
 4. Repeat until the lather no longer discolors.
 5. Rinse until the rinse water is clean.
 6. Air-dry the brush with the bristles hanging down.

Duplication Procedures

Duplication of negatives to produce copies should be made at this point. Large institutions and custodians of large photographic collections should consider this step after cleaning. In the case where the artifact is damaged and requires stabilization, the duplication should be completed before the photograph is isolated, after which the image can no longer be observed directly.

This topic is detailed in numerous references provided in the bibliography.

SPECIFIC STABILIZATION PROCEDURES

As a result of the examining, sorting, and cleaning operations, photographs will have been grouped into well-defined categories (see Chapter 3). Each of these categories will require a specific stabilization procedure to prevent further damage and preserve the damaged artifact until treatment can be undertaken. The following are specific stabilization procedures that will be useful in most collections.

Nitrate Materials (Plastic Supports)

1. Identify these materials within the collection and isolate them as quickly as possible.

2. Determine the degree of deterioration by applying a water spot test to the

emulsion. Yellow-brown and discolored image-layers may have become water soluble due to deterioration in very acidic environments.

3. Water-soluble emulsions are unstable. Immediately clean and photographically duplicate these artifacts. Sticky nitrates cannot be cleaned and must be duplicated immediately, if possible, and destroyed (for disposal of nitrate materials, contact the fire marshall in your area). Stable nitrate-based materials can be duplicated later; if stored in a low-temperature environment, they may not require duplication.

4. After cleaning, place these artifacts into buffered paper enclosures. Do not use plastic sleeves because these will trap the decomposition products within the sleeve and will significantly increase the rate of deterioration.

5. Store decomposing material in an isolated area separate from other photographic materials. Refrigeration is recommended.

6. Nitrate materials stored at room temperature must not be placed in sealed containers, as the gases produced from decomposition must be allowed to escape. The storage area must be well ventilated, preferably out of the building.

Diacetate Materials (Plastic Supports)

1. Identify these materials and isolate them from the collection.

2. Clean and photographically duplicate them as quickly as possible. The loss of plasticizer from the plastic base results in shrinkage of the base and a blistering and release of the gelatin binder. Duplication before this occurs is the only expedient way of preserving the record.

3. After cleaning, place materials into buffered paper enclosures.

4. Store all of the diacetate materials in the same storage area. It is not imperative to isolate them from the other collection materials, but if space is available store them in a separate area.

5. Refrigeration is recommended; preparation for storage is the same as that given for nitrate material.

6. Acetate material can be stored at room temperature and it should be sealed into containers to try to keep the loss of the plasticizer to a minimum.

Broken Glass Plates (Glass Supports)

1. Lay the envelope containing the plate onto an auxiliary support, larger in size than the artifact, with the emulsion side up.

2. Carefully cut the edges of the paper envelope with a scalpel along two of the jointed sides until the top or cover piece can be lifted away from the plate (Figure 4.8).

3. Each piece of the broken plate should be removed and cleaned on both sides, as described earlier. It is very important that the swabbing motion begin in the center and continue outward to the edges. The primary concern is to avoid tearing or abrading loose pieces of emulsion which may be extending or hanging over the edge of the break. Place the clean pieces onto a clean auxiliary support with the emulsion side up.

4. Prevent the pieces from contacting each other, since this contact could cause further damage by abrading the loose emulsion pieces.

5. Information from the old envelope should be transferred to the new enclosure as well as the accession number and a brief description.

6. Once cleaned, wrap each piece in Silversafe tissue paper (Figure 4.9), and transfer to a labeled enclosure of an appropriate size.

7. Keep all of the glass pieces, including the splinters, together during storage, each group in its own labeled envelope.

A variation of this procedure that results in less damage to the photograph and takes less space is included in this section. The method requires some skill and ability in cutting beveled edges:

1. Cut a set of windows into a piece of 4-ply mattboard that is about ½ inch larger in size than the artifact. A second sheet will be used as the stabilizing board and the information should be transferred to it instead of the enclosure mentioned above.

2. Place all of the glass fragments, in their proper positions, onto the 4-ply mattboard, emulsion side down, and trace the outline of each piece in pencil (Figure 4.10). This operation needs to be repeated for all of the pieces of broken glass. Remember to leave about ¼ inch between adjacent pieces.

3. The various pieces are now cut freehand out of the mattboard, insuring that

there is a slight bevel to the cut and that the graphite line is removed after cutting through (Figure 4.11). These windows are cut exactly as the matts described in Chapter 6, but because of the irregular forms and shapes it is not possible to use a matt cutter.

4. The various pieces are now installed into the window cavities, emulsion side down, and taped into place with Filmoplast or Archival Repair Tape (Figure 4.12). It is important to note that the tape is contacting the glass side and not the emulsion side.

5. The entire assembly is now placed onto a sheet of 4-ply mattboard, which has double-sided tape (3M 415) along the edges. A sheet of 4-ply mattboard is hinged with linen tape to the top of the package. Label information is located on the top board.

Cracked Glass Plates (Glass Supports)

With a cracked glass plate, particularly a gelatin glass plate, a stabilizing support is required in order to restrict further cracking. The glass may be cracked, but the gelatin image layer is still complete, and in many cases the emulsion is the only thing still holding the plate together. The stabilizing supports must be exactly the same size as the photograph and these are taped together with the artifact to provide additional rigidity.

1. Lay the enclosure containing the plate onto a flat surface, such as a rigid auxiliary support, which is larger in size than the photograph, and with the emulsion side facing down.

2. Carefully cut the paper envelope edges, using a sharp scalpel and straight edge, as instructed for broken plates. Take care not to damage the photograph.

3. The removal of the top layer of the paper envelope will allow the problem to be observed clearly. Carefully clean the glass side of the photograph.

4. Place a 3mm. (⅛-inch) glass stabilizing support of the same size as the photograph on top of the plate and carefully turn both over together by sliding them over the edge of the auxiliary support to attain a proper grip (Fig 4.13). The glass-stabilizing supports can be purchased in bulk, and should have the edges polished to reduce cuts from handling.

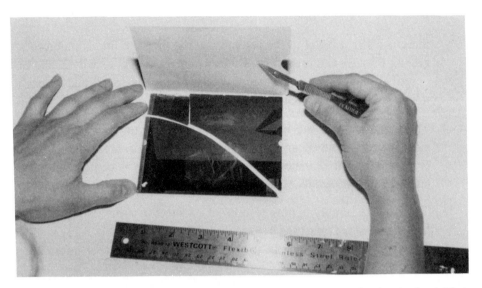

Fig. 4.8 Cutting open an envelope requires great care. The contents need to be clearly visible to allow appropriate action to be taken.

Fig. 4.9 Wrapping these pieces can result in damage to the binder, but in situations where skilled technicians and resources are unavailable, this may be the only possible course of action.

Fig. 4.10 The use of a pencil to mark out the edge of the plate requires care to insure that the graphite does not contact the artifact.

Fig. 4.11 The free-hand cutting operation with a matt knife is required to provide custom shaped contours that match the shape of the various glass fragments.

Fig. 4.12 The Filmoplast tape may have to be applied in several short lengths to conform to the irregularly shaped cracks. The tape is applied to the glass side and overlapped onto the mattboard cutout.

Fig. 4.13 Glass is used as the stabilizing support in an attempt to restrict the glass plate from any movement at all.

5. Clean the exposed surface of the still-intact emulsion. Place a piece of 4-ply mattboard cut to the same size as the plate on top of the emulsion and tape the assembly together with Filmoplast or Archival Repair tape along the edges.

6. A label should have been added to the mattboard prior to assembly, containing the accession number and a brief description of the problem. The stabilized glass plate should be stored horizontally until future conservation can deal with the problem.

7. If a portion of the glass plate has broken free and been lost, an insert is needed to insure that the stresses during handling are distributed evenly and do not contribute to further damage of the plate. This is done by tracing the outline of the loss on a piece of 2-ply mattboard. This segment is cut out and inserted into the void, using a cotton batting spacer plug between the artifact and the mattboard. The mattboard should be approximately the same thickness as the artifact.

Lifting Emulsions (Most Supports)

Emulsions that are lifting away from their supports generally indicate photographs which have been exposed to extreme environments of temperature and relative

humidity. The stresses associated with these conditions result in the emulsion pulling free of the support, usually at the outer edges where the stresses are greatest.

1. Clean the emulsion without causing an increase in the degree of lifting and, if possible, also flatten the emulsion down into its proper position (Figure 4.14).

2. Place a 4-ply sheet of mattboard, cut to the size of the artifact, at one edge. This stabilizing support is lying on the emulsion. The first step is to lay it down onto the flattened portion, reposition the raised emulsion, and advance the piece of mattboard until the entire surface has been laid down. It will be necessary to advance the mattboard slowly, laying down the emulsion immediately in front of the board.

3. Turn the unit over and check the positions of the various loose pieces. If necessary, reposition them. There may be situations in which the emulsion has been folded over on itself and it refuses to be repositioned into its proper location. Do not attempt to force these pieces into place, since the damage

Fig. 4.14 The bone folder is applied with light pressure to prevent the lifted binder from moving during cleaning and repositioning.

that might be done will be irreversible. Allow the folded piece to remain in its position.

4. The entire package is taped with either Filmoplast or Archival Repair tape. The information associated with the photograph, its accession number, and a brief description of the problem, should have been written on the outside of the 4-ply mattboard prior to assembly.

5. Clean the glass side with Kodak Film Cleaner and place the package into a paper enclosure. Label this enclosure and store for future conservation.

Flaking Emulsions (Most Supports)

Flaking emulsions result when the binder has been attacked chemically or after extreme desiccation. Do not attempt to clean a flaking emulsion. The delicate pieces and friable binder will be further damaged through handling. Isolate the artifact, then photographically duplicate the image and protect the emulsion by using the sandwiching procedure outlined for brittle supports.

Fused Material (Most Supports)

This problem occurs primarily with gelatin binders that contact another smooth surface while wet. The fusion of the gelatin emulsion to another gelatin emulsion, or to the paper envelope in which it is stored, are the most common examples of fused materials. Gelatin prints, which are framed without a matt, may also adhere to the glass glazing if they get wet.

1. Do not force the separation of material that has fused to another surface. If forced to release, the emulsion will usually be torn from its support, but will still adhere to the other item.

2. Lightly dust all of the exposed surfaces with the dusting brush.

3. Clean all of the exposed surfaces, without stressing the fused area or joint connecting the photographs.

4. Label an enclosure with the necessary information, including the accession number and a brief summary of the problem; then place the fused items into an enclosure to await conservation.

5. Insure that these photographs are stored horizontally, and that nothing is placed on top of them which might apply pressure to the surfaces.

Lantern Slides (Glass Supports)
Lantern slides are a composite made up of the image, binder, and support which is encased by a paper matt and cover glasses and bound up with a black paper tape. The most common damage is cracked or broken cover glasses.

1. Clean the cover-glass surfaces with Kodak Film Cleaner.

2. If a cover glass is broken or cracked, carefully cut the tape binding the assembly, and remove and clean its various components.

3. Replace the cover glass (if broken, have a new one cut) and retape the assembly, using Filmoplast or Archival Repair tape.

Oversize Mounted Prints (Paper Supports)
The common problem with mounted prints, particularly the oversize materials, is a brittle mount support that breaks, and that in turn breaks off a piece of the print attached to the mount board.

1. In situations such as these it is best not to attempt to remove the print from its mount, even if lifting corners provides an opportunity to begin this operation.

2. Handle this type of artifact with both hands and place it on an auxiliary support to insure that it is not stressed. Remember that the mount may be brittle and that if a corner is broken off because of mishandling, it may take a piece of print with it.

3. A mounted print with a strong bowing or curvature should be cleaned and placed between two pieces of buffered mattboard with a concertina fold for the link piece between the cover and back boards. This housing allows the bowed print to be stored without flattening. Store the folder horizontally and prevent objects from being placed on top of it since it might break if pressed.

4. Before inserting the mounted print into the folder, place the print, emulsion side down, on a clean sheet of paper over a flat, rigid surface, and weight it down with several padded weights.

5. Clean the back of the mount with eraser rubbings powder, as described earlier, and be careful not to allow the eraser powder to get onto the emulsion.

6. Dust well and turn over and complete the dry cleaning of the paper mount. Remember to use an auxiliary support for brittle materials.

7. Clean the print emulsion with Kodak Film Cleaner and store in an appropriately sized, buffered enclosure. It may be necessary to prepare a custom-made folder with the concertina fold.

8. Transfer all of the information to the new enclosure and store for conservation.

9. It is imperative that this type of photograph be stored flat in a horizontal drawer or solander box. Don't allow these items to be stacked into a pile, one on top of another, if they are either brittle or curved.

Unmounted Brittle Prints (Paper Supports)
Brittle Negatives (Plastic Supports)

1. Prints stored in the same enclosures with nitrate negatives as well as these cellulose nitrate negatives often become acidic and brittle during storage. Such a photograph will be very fragile, requiring that the envelope be cut away with a scalpel. Take care not to cut the print.

2. The print, or negative, is measured and two stabilizing supports of buffered 4-ply mattboard are cut slightly larger in size. The photograph is provided with a safe zone around the perimeter, and in the case where the item has broken into several large pieces this safety edge should include a spacing of about ¼ inch between the broken pieces.

3. Slide the various component pieces, emulsion side up, across the auxiliary support onto one of the two pieces of mattboard. This operation may require care and delicate manipulation; the use of a pair of tweezers will help in sliding and placing the pieces on the new mattboard (Figure 4.15).

4. Sandwich the photograph by laying the second mattboard over the first one and tape along one of the long edges with Filmoplast or Archival Repair tape. Take care to insure that the contents do not slide during these taping steps.

5. Check the position of the various pieces by opening the hinged mattboard; if the contents have shifted, reposition them. Finish taping the other four sides of the package.

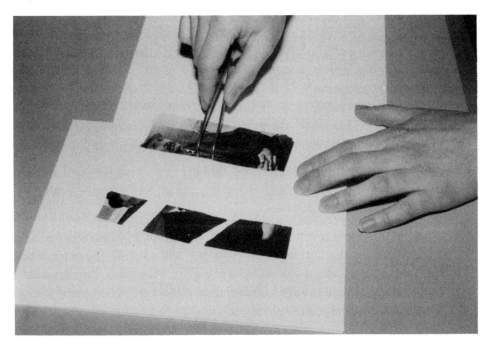

Fig. 4.15 The brittleness of the print prevents its being picked up. The transfer of the different pieces is accomplished by sliding them on auxiliary supports.

6. The top sheet of the mattboard should be labeled, prior to assembling, with the pertinent information, including the accession number or catalogue number as well as a brief description of the problem contained within the housing. Store for conservation considerations to be applied at a future date.

Note: It will not be necessary to isolate the pieces, as for broken glass plates, because once the sandwich is taped closed, the pieces will not have a weight great enough to slide about.

Curled Prints (Paper Supports)

These are often panorama prints, usually large group photos, with unusual dimensions. This unusual, long rectangular format often meant that the prints were stored rolled. Extended periods of time in a rolled form tend to produce prints and, in some cases, negatives that are tightly curled and cannot be unrolled easily.

Strongly Curled Prints

1. If a roll of rigid, tightly rolled prints is forced open and flattened, the emulsion and paper or plastic support may crack or tear.

2. The first step is to place the print over a mailing tube that has been wrapped with acid-free paper (Figure 4.16), and that has a diameter a bit larger than the rolled prints. The tube should extend at least one inch beyond the edges of the print.

3. Roll the curled print onto the tube. After the first revolution, add a sheet of acid-free interleaving tissue and continue to roll the assembly together.

4. Once the entire print has been rolled onto the tube, wrap the outside of the print with acid-free tissue and secure it with several strips of 6 mm. (¼ inch) unbleached cotton tape.

5. Tuck the excess tissue paper into the tube end and store with an identification tag attached to the cotton tapes. This tag will provide the information concerning the accession number and any other information concerning the print. This is a rolled storage format and the roll is kept in horizontal storage for subsequent conservation.

Fig. 4.16 The transfer of a print to a new tube may require the help of another person. Prints which have been rolled for extended periods of time will be particularly difficult to handle.

Mildly Curled Prints

1. These are prints which can be safely unrolled without cracking or breaking the print emulsion.

2. Place the print onto a clean sheet of blotting paper, emulsion side down and weigh it down with padded weights.

3. Place a fresh sheet of blotting paper over it and slowly remove one weight at a time, reweighting the blotter.

4. A sheet of glass, larger in size than the print and blotters, is then placed on top of the blotter.

5. Leave this package for several days, checking it at regular intervals, to see if the curl has been reduced. A slow and controlled increase in the relative humidity in the space or the use of a humidity tent will increase the rate of relaxation of the curled print, but be careful that mould growth does not occur.

6. Clean and place in an appropriately sized enclosure or folder with the appropriate information recorded on the package.

Albums (Paper Supports)

Albums generally contain prints, but may include photographs with other base supports. The problems associated with albums are often structural failures of the album itself, particularly the manner in which small mounted items were contained within the album page. An album, even though it might be falling apart structurally, should be maintained as an entity.

1. Clean the album binding by dusting with a soft brush.

2. Dust all accessible print surfaces, but do not remove the photographs from their pages if the step is not necessary. Interleave each page of the album with Silversafe tissue, cut slightly smaller in size than the page.

3. Loose items stored between pages should be cleaned and placed into labeled enclosures. These should be stored with the album, in a box constructed to hold the album and these extra items, with a notation of the page on which they were found.

4. Prints that are becoming loose should be removed from the album and handled separately.

5. The size of some albums, particularly very thick ones, may necessitate wrapping them in several sheets of acid-free tissue, then binding them with unbleached cotton tape. Ideally each album would have a custom made box for storage purposes.

6. Attach a label listing the information about the album to the cotton tape used for wrapping the artifact and store it horizontally.

Case Photographs (Metal and Glass Supports)

If a photograph has a metal support, it is either a daguerreotype or tintype. The daguerreotype and the ambrotype (a photograph on glass) are almost always found in an ornamental case. These cases include a number of different formats and in general are easily damaged, particularly in situations where individuals attempt to remove the ornamental package from the case for examination.

Removal of the Artifact from the Case

1. Open the case by releasing the side clasps on the case. Be careful: the case may be in two parts, due to a torn hinge.

2. Slide the end of a flat spatula into the space between the case and metal frame holding the photograph. Carefully and gently pry up the entire package (see Figure 2.13). Don't apply excessive pressure because the case walls will collapse and the wooden corners of the case will open.

3. Once the internal package has been raised sufficiently to allow handling, remove the assemblage. This unit consists of four items: the photograph, matt, cover glass, and outer metal border matt (Figure 4.17).

4. Do not disassemble this unit unless the cover glass is broken, cracked, missing, or excessively dirty. The deterioration of the cover glass often includes small beads of material bound in the glass falling to the artifact surface and causing localized deterioration, particularly on the daguerreotype plate.

5. To remove the outer brass metal binder or border matt, gently flex the lips which extend onto the back of the unit. If flexed too far or too often, the corners of the metal binder will break. Do not take this assembly apart unless it is absolutely necessary.

6. The remaining parts of the assembly are usually bound with paper tape.

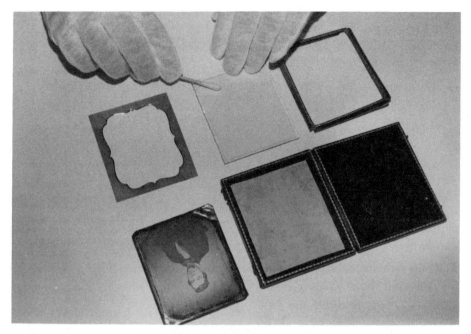

Fig. 4.17 The entire contents of the case are displayed here and the cover glass is being cleaned using film cleaner.

Carefully slit this tape with a scalpel. The entire package must be rebound with tape, so do not break this seal if you cannot reclose it.

7. The entire assembly is now free, and the cover glass, matt, and photograph can be removed for treatment. Be careful: the metal matt may slide, damaging the delicate image-carrying surface.

8. The cover glass is cleaned or replaced (use the cleaning solution described on page 86). If the matt is missing, it is replaced with one piece of 2-ply mattboard, similarly cut. The outline of the original matt may be apparent on the image.

9. Clean the various photographic items. (See subsequent sections for details.)

10. Reassemble the unit and close by binding it with Filmoplast or Archival Repair Tape. Return the outer metal binding border and carefully insert the entire package back into the case.

11. If the case is broken, place the two halves together without locking the clasps. Wrap the case in acid-free tissue and tie up with 6 mm. (¼-in) unbleached cotton tape. In some situations an appropriate housing, such

as the Protective Box for Cased Objects (see Norris, page 174), or a clamshell-style box can be custom built.

12. Store these items horizontally and in dedicated boxes.

The Daguerreotype

1. Do not attempt to clean daguerreotypes. The image layer is sensitive to mechanical abrasion. The damage most commonly observed on daguerreotype images without cover glasses is a loss of the image from cleaning attempts with a polishing or buffing method. The chemical deterioration of the daguerreotype plate often obscures the image, and individuals not familiar with the process try to remove this discoloration by wiping the surface.

2. If the plate is loose, and the case and other components have been lost, cut 2-ply mattboard window matt with 6 mm. (¼-in.) wide borders, and place this over the plate (Figure 4.18).

3. Cut a piece of glass to size and place it over the assembly. Tape it all together with Filmoplast or Archival Repair Tape.

4. This package should be placed into an appropriate box and the label information placed inside the package. If box storage is not available, wrap in acid-free tissue and store in a horizontal position.

The Tintype

1. The most common damage observed with tintypes are bends and distortions in the thin metal support. In paper presentation pages and albums, these images appear loose. It is also possible that they will be found in cases, but this is usually a configuration that people applied from other artifacts. Casing a tintype was not a presentation format provided by most photographers.

2. The tintype may also display a lifting image layer where the binder is blistering, due to rust generated from underneath.

3. The approach for slightly bent plates is to prepare a cover glass and mattboard matt and to sandwich the entire unit together with paper tape in the same manner as the loose daguerreotype.

4. For badly bent, loose tintype plates, a package may be needed that isolates

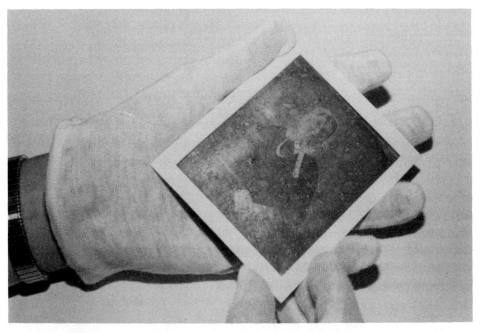

Fig. 4.18 The new mattboard matt is just large enough to provide a spacer for the cover glass to prevent it contacting the photograph's surface.

the plate. The same procedure used for brittle prints and negatives should be used: isolate the artifact between two pieces of mattboard and tape these two together.

The Ambrotype

1. The ambrotype is a collodion glass plate negative with an application of a black lacquer coating on the nonemulsion side, rendering it a positive image. The most common deterioration is this black lacquer layer flaking off.

2. After removal of the cover glass, metal matt, and metal binder from the case, clean the various components by lightly brushing both sides of the assemblage.

3. Before disassembling the unit, lightly rub the flaking surface with a dry cotton swab to dislodge any of the loose lacquer that is blistering, and dust the unit again.

4. Disassemble the unit as for the daguerreotype and clean the cover glass, replacing it if necessary. The ambrotype should not be cleaned except for dusting.

Photographic Art Prints (Paper Supports)

These photographic prints are processes that have an image quality that could be confused with graphic print processes. They include such processes as carbon, carbro, oil, bromoil, oil transfer, and gum bichromate.

1. Do not attempt to clean these photographic prints. The cleaning methods described earlier are applicable primarily to gelatin, albumen, and collodion binders. Some of these processes do not have binders or structures that lend themselves to these cleaning procedures.

2. If process identification has been indeterminate, it is best to request the services of a qualified conservator rather than risk damage.

3. Figure 4.19 is an example of a gum bichromate print. The image quality and image characteristics can be very different from the qualities associated with gelatin silver prints.

Fig. 4.19 This gum bichromate print displays the unique image quality associated with this fine art process. The identification of the photographic processes is imperative before application of treatments. *Robert A. Thurn, New Pictorialists Society, Permanent Collection.*

<div align="right">**5**</div>

Environments for Photographic Materials

The environment in which artifacts—and particularly photographic artifacts—are used, exhibited, and stored determines their rates of deterioration and therefore their longevity. The various deteriorative effects have been discussed in Chapter 3; this chapter is specifically designed to define the optimal environmental parameters for storage, use, and exhibition.

The elimination, or at least the control, of those conditions that promote or induce deterioration will promote permanence. The care in preparation of photographs and the use of quality materials with them are also important if these preservation parameters are to be maximized. Ideally, any given photograph would be securely put away with limited access and no exposure to undesirable conditions. The ability of any one person, collection, or organization to do this is limited. In general it is the goal of conservators and curators to protect and promote the welfare of all the artifacts in their care while still providing access to them for scholars and patrons, while trying also to limit the impact of such access on the artifacts themselves.

This self-evident truth and obvious goal is a most difficult one to achieve; it involves the direct control of the following parameters previously discussed in Chapter 3:

 relative humidity
 temperature
 light levels
 air quality
 cycling conditions

as well as parameters associated with the intimate environments immediately contacting the photographs including:

1. Quality of paper and boards used as housings for photographs
2. The inherent problems of instabilities (internal vice) within the photographs themselves

The deterioration of a photograph is due to the interaction of several different environmental parameters; all environments have some deterioration or loss of quality associated with them. Since the degree of loss is a function of many variables, the control of those variables will allow the deterioration rate to be controlled.

GENERAL ENVIRONMENTAL PARAMETERS

Relative Humidity

Relative humidity is a measure of the amount of water vapor present around us at any particular point in time compared to the maximum amount the air can hold at that particular temperature. It is expressed as a percentage. The ability of air to hold water moisture increases as the temperature rises and decreases as the temperature drops, the total volume of air being equal.

In situations where the environment is uncontrolled, the moisture content of the air changes on the basis of the change in temperature and the amount of water available for absorption as water vapor. A rise in temperature allows an increase in the amount of water vapor that can be held by the air. If water is present in excess, the moisture content of the air increases, even though the relative humidity remains the same. The opposite situation occurs when the temperature drops and the ability of the air to hold the moisture reaches a limit; excess moisture is released as water. This situation is referred to as the dew point.

Relative humidity, the amount of moisture in the air, must be controlled to prevent or at least minimize the changes in moisture content. The changes of organic-based artifacts in fluctuating relative humidity environments are considerable, since the materials absorb and desorb water moisture readily. This process can result in dimensional changes and stresses. The case with inorganic materials is more a matter of corrosion due to high relative humidities.

Temperature

Temperature and relative humidity are closely related. Temperature is the immediate factor involved in the rate of chemical deterioration of materials. The

rate at which chemical reactions proceed, including deterioration reactions, is based on the temperature. The control of temperature is important because of its relationship to relative humidity, and because the rate at which the various deterioration reactions operate are also temperature controlled.

The relationship between the rate of chemical reactions and the temperature at which the reaction occurs was resolved by chemists as the Arrhenius equation. The rule of thumb for reactions involving water is that for each rise in temperature of 10°C the reaction rate approximately doubles. The rate of deterioration of materials, particularly organic materials which have a water-absorption capability, shows a similar relationship in terms of the increased deterioration rate with increased temperature.

The same relationship holds for lower temperatures: the rate of deterioration slows as the temperature drops. This relationship is used in storage practices for contemporary color materials. These have organic dye images that show relatively poor chemical stability; they are stabilized by low temperature, cold storage.

Light Levels

The problems associated with damage due to light are compounded by the fact that light is required for the photograph to be used and viewed. Light, like heat, is a form of energy, and the rates of deterioration are also affected by the levels of light intensity as well as duration of exposure. This is particularly the case with organic materials, which can be irreversibly altered by exposure to light during exhibition or examination.

The various components or colors of light affect the deterioration of photographs at different rates. The ultraviolet and blue end of the spectrum are more damaging than the yellow and red end. The elimination of the ultraviolet and a small portion of the blue light in the viewing conditions for the photograph helps reduce photochemical damage. This is done by using ultraviolet absorbing glazing in frames and cases and by using incandescent light for exhibiting the photographs.

While the elimination of the blue and ultraviolet components of the light is important, the intensity of the light must also be controlled. The energy of the bright light sources provides additional energy, which translates into increased rates of deterioration for many materials. The general trend seems to be an increased rate of deterioration for increased levels of intensity; for this reason, light levels will also require control.

Air Quality

The quality of the air in the environment associated with photographs has two components: a chemical one, which involves chemical deterioration processes; and a physical one, which involves mechanical damage.

The chemical problems are associated with gaseous pollutants that may not be eliminated or neutralized by the air-handling units attached to the storage areas. In general these gases are from an external source, such as industrial or urban pollution. But there are situations where the problem might be internal, where the source of the gases is from the collection materials themselves.

The gases of greatest concern to us are oxidizing gases, such as sulfur dioxide, nitrogen dioxides and peroxides, and ozone. The most common sources of these include the by-products of automotive and industrial processes based on fossil fuel combustion, cellulose nitrate photographic collections, and electrostatic copy machines.

The physical problem is particulates suspended and held in the air. Many of these are gritty and damage the sensitive image-binder layers of photographic materials during handling. They can be removed with a series of fine filters through which the air is passed before entering the materials' environment. The filtering of outside air before it enters the area is important, but so is filtering the recycled internal air for particulates which may have originated from within the photographic environment.

Cycling Conditions

The impact of the various environmental factors is compounded when examined in terms of cycling or uncontrolled conditions. Each of the variables discussed has an impact but they all occur together and as such can have a compound effect, particularly when uncontrolled and free to fluctuate.

The greatest impact on the photographs results from the uncontrolled conditions associated with relative humidity and temperature. The strains and stresses introduced result in mechanical damage; elevated conditions of these two variables result in significantly increased deterioration rates. The fluctuation of these basic conditions over time, particularly the type of daily cycling expected in an uncontrolled space, results in the rapid deterioration and demise of the photographs.

ASSOCIATED MATERIALS

Intimate Environmental Considerations

The immediate and intimate environments of the photographs, particularly the storage areas, are the best places to view the results of using poor-quality or inappropriate materials. Photographers still store their processed materials in the containers in which they were purchased (Figure 5.1).

The sensitized product, packaged in sealed units and protected from outside influences, is not adversely affected by the container. The quality of the materials used in that same container is adequate only for physical protection, since chemical problems are resolved by sealing the package.

The results of poor-quality storage products, usually in the form of cardboard boxes and paper envelopes, are visible in most collections. The practice of replacing processed microfilm in the original box results in the formation of microscopic blemishes. This in turn can be traced to the evolution of peroxide gases evolving from the low-quality cardboard boxes used to package the original product.

This case study explains the results of deterioration of silver-imaged photographs in direct and intimate contact with cardboard boxes such as those used to market early plates and films.

Fig. 5.1 This is a common example of the configuration in which many collections are acquired. Photographers often used the original packaging to store processed photographs.

Housing Material Quality

The quality parameters associated with the proper housing materials for photographs are discussed in Chapter 6. In general, the need for chemical purity and inertness is the primary concern. The style of the housing will depend upon the needs of the photograph and will insure that the housing does not cause physical damage to it.

Chemical parameters include paper products made of high-quality fibers with minimal residual processing chemicals and low values of specific chemicals, including sulfur and sulfur compounds, and chlorine and chlorine compounds. The use of buffering compounds is eliminated except in a handful of special cases where buffering provides a specific and necessary role.

Physical parameters are related to the style and function of the housing in relationship to the artifact. The elimination of seams and multiple layers which could emboss themselves on the physically sensitive layers of photographs is a prime concern.

Artifact Quality

The quality of the photograph itself may be a contributing factor to the environment, particularly as it relates to other photographs sharing the same space. The presence of poorly processed photographs in close or intimate contact with properly processed materials can lead to chemical deterioration problems by diffusion or transfer.

The transfer by gaseous methods is even more significant. Problems are most often seen with cellulose nitrate materials stored in the same environment as other silver-based materials. The decomposition by-products of the deterioration of cellulose nitrate include nitrogen dioxide and nitrogen peroxides. These gases readily diffuse out of their immediate storage areas into the rest of the storage space. The gases combine with moisture in the other organic artifacts to form nitric acid and bleach out the silver images, embrittling the gelatin binders and paper supports.

The segregation of these types of problem materials and control of the rate of deterioration must be a high priority in collections containing cellulose nitrate.

MONITORING ENVIRONMENTAL PARAMETERS

Relative Humidity

The measurement of the relative humidity in specific areas of the gallery or storage areas can be accomplished by the use of a hygrometer. Spot measurements in

areas not normally monitored by a hygrothermograph are done with an instrument such as this.

There are several models available in different cost ranges. The sling psychrometer is an inexpensive wet/dry bulb instrument. The Bacharach sling psychrometer is a relatively inexpensive instrument. The temperatures of two different thermometers, one dry and the other wet, are read and the difference between the two temperatures is read from a chart to determine the relative humidity. The Bendix wet/dry bulb hygrometer is similar to the sling instrument but an incorporated fan is used to cool the wet bulb.

Electronic hygrometers are more expensive instruments. The sensor is electronic and after a short conditioning and calibration check the instrument is ready for use. Its advantage is in its ease of use—the reading is direct. The electronic instrument of choice would be the Humi-Check IV, which can be used to check the calibration of the hygrothermographs discussed in the next section.

There is a very inexpensive humidity-monitoring strip that has low sensitivity and poor accuracy but that is good for obtaining a ballpark determination of the relative humidity within a space. This strip of small squares of a chemically impregnated paper is mounted on a cardboard strip. The impregnated squares are sensitive to moisture and color either blue or pink depending on the moisture content of the air around them. The squares are divided into units of 10 percent relative humidity and the reading is taken from the interface between the blue and pink squares. These strips are manufactured by Multiform Desicants Inc. of Buffalo, NY.

Relative Humidity and Temperature

The hygrothermograph records two variables, relative humidity and temperature. These two parameters are recorded as pen lines on a rotating drum which has an attached recording graph paper. The recorded values indicate the values and ranges of fluctuations which the environment has gone through; they provide a monitor of the ability of the air-handling physical plant to service the area with the desired relative humidity and temperature. The hygrothermograph model usually chosen for monitoring spaces has a 31-day duration chart; the staff must change the graph paper monthly. Some instruments can also provide one-week or one-day duration scales. All of the critical areas in which photographs will be kept—the collection storage, display, and exhibition areas—should have recording hygrothermographs.

There are a wide range of recording hygrothermographs available. The rec-

ommendation for a 31-day recording instrument is the Weathertronics 5000 series, particularly the 5020. This unit can be converted to a 7-day instrument by changing a gear on the drum. The use of a clock drive that requires winding each time the chart paper is changed is preferable to the battery-driven models. The battery may give out between chart-paper changes and result in a void in the record.

The hygrothermographs should have human hair bundles for the humidity sensors and bimetallic strips for the temperature sensors. The range need not exceed the nominal ranges for which most of these instruments are manufactured, but special ranges can be included if cold rooms are to be monitored. The normal range is 0 to 100 percent relative humidity and 20° to 100°F. The accuracy should be plus or minus 3 percent relative humidity and plus or minus 1°F.

There is a set of recording instruments carried by Cole-Parmer that are reasonably priced and can be placed in small spaces such as display cases as well as storage and patron-use areas. The largest selection of devices, however, is carried by Abbeon Cal. Inc. Their catalogue is invaluable for small tools and instruments.

Light Levels

Light intensity levels in the exhibition and display spaces are measured with a photometer, either a lux meter or a footcandle meter. These instruments provide spot readings of the light intensity; the maximum value defined for most photographic display applications is 50 lux or 5 footcandles. The Gossen Pan Lux meter or Footcandle meter is an excellent instrument for this task.

The proportion of ultraviolet light in the lighting is of concern and is measured with a UV meter. This instrument measures only the ultraviolet component of the light. The presence of ultraviolet and blue light causes the photochemical deterioration of artifacts, particularly organic materials. The upper limit is set at less than 75 microwatts per lumen. The Crawford UV monitor 760 is the only instrument appropriate for use by nonspecialists.

Incandescent lights that have a low ultraviolet component but which throw considerable heat are being replaced in some applications by filtered or shielded fluorescents. In general, exhibition spaces should continue to use incandescent lamps.

Biological Activity

The presence of an active, biological infestation can be determined by using an ultraviolet lamp and illuminating the surface of the photograph. Active fungus

and mold colonies will show a fluorescence in the areas in which they are active. Contemporary photographs will show fluorescence as a uniform color over the entire sheet; this should not be confused with the circular colonies of biologically active infestation, which are distributed across the surface in a random pattern.

The use of ultraviolet light sources must be accompanied by the use of safety glasses. These glasses will protect your eyes from damage that can occur from the use of a short-wave ultraviolet lamp during examination.

Air Quality

The monitoring of air quality and detection of particular pollutants and oxidizing gases is a specialized procedure beyond the abilities of collection staff. The study of a problem of this sort will require specialists to study and sample the air in the space and report their findings. The ideal method would be to apply the practices outlined in this chapter to prevent the entry of particulates and pollutants into the space.

USE AND APPLICATION OF MONITORING INSTRUMENTS

Relative Humidity and Temperature

Bendix Psychrometer
Psychro-Dyne Psychrometer
Both of these instruments are battery-operated, fan-cooled psychrometers. The instrument has two thermometers, one with a sock attached to the bulb. The thermometer with the sock on is called the wet bulb because it is wetted with several drops of distilled water (Figure 5.2).

The temperature of this thermometer bulb will begin to drop shortly after the application of the water. The process is accelerated by the use of a fan. This is an evaporative cooling fan which functions on the basis of the relative humidity of the surrounding air. The reading will depress until the evaporative cooling is balanced by the normal heat gain from the surrounding air. The two temperatures, that of the dry bulb and the wet bulb, are noted and the difference calculated.

The dry bulb temperature, and the difference between the dry bulb and wet bulb, are then correlated with hygrometric tables to determine the relative humidity. A slide ruler is also provided to allow a faster calculation of the relative humidity for applications where accuracy is not as important.

Fig. 5.2 These instruments represent temperature and/or humidity measuring and monitoring tools. The card in the foreground is a humidity indicator made by Multiform Desicants. Proceeding clockwise is the sling hygrometer, the Bendix psychrometer, the hygrothermograph and the Humi-Chek.

Suppliers:
 Bendix Psychrometer VWR Scientific
 Fisher Scientific
 Psychro-Dyne Psychrometer Abbeon Cal Inc

Humi-Check Hygrometer and Thermometer

This instrument is an electronic hygrometer and thermometer. The sensor is stored separately from the body and is installed just prior to use. The instrument is calibrated by using a saturated salt solution packaged with the unit and designed to fit around the sensor. The calibration and reading operations are conducted by pressing selected buttons on the handheld control board and the readings are digitally displayed (see Figure 5.2).

The readings are quick and accurate and the instrument is ideal for spot testing the various areas of the building and for checking the existing recording instruments and their calibration.

Supplier:
 Humi-Chek Beckman Industrial

Weathertronics Recording Hygrothermograph
Casella Recording Hygrothermograph
This instrument provides measurements of two different parameters, temperature and relative humidity. The temperature scale can vary in its recording range but the relative humidity scale on the recording graph paper will generally be 0 percent to 100 percent. Avoid the type of product that incorporates both parameters together on the same scale. These are difficult to read, particularly if you have forgotten which pen colors are used to record the different parameters. The circular recording instruments, in which the output is on a circular graph, are also to be avoided. The impact of any given event is difficult to interpret with these types of instruments.

The calibration of these instruments must be checked from time to time. Commercially available services can be obtained for the calibration process from climate engineering firms. The instruments should be calibrated once every 12 months, and a periodic cross check should be made against the Humi-Chek or sling hygrometer. Major differences between the two instruments indicate the need for recalibration. Do not attempt to calibrate the instrument yourself.

The maintenance of the instrument involves changing the recording graph paper at the required intervals. The pens require replacement from time to time and the clockwork requires winding whenever the paper is changed. Do not use reservoir pens; disposable pens are easier to install and cleaner to handle (see Figure 5.2).

Supplier:

| Hi-Q Hygrothermograph | Weathertronics |
| Casella | Carleton Instruments |

Light

Gossen Panlux Luxmeter
This instrument is available for measurements in either lux or footcandle units. The meter is attached to the reading head by several feet of connecting wire and the reading head is placed at the object, parallel to the face of the object and just in front of it. The orientation of the reading head is adjusted to emulate the light falling on the artifact (Figure 5.3).

The measurement is read by activating a push button on the side of the meter, and the scale is changed by flipping a dial located on the other side of the meter. The battery check is conducted by flipping a second dial located just below the

Fig. 5.3 These two instruments are used to monitor light. The lux meter on the left is made up of two pieces, the scale component and the sensor. The instrument on the right is the UV meter.

scale dial. The reading head also has a flip switch that allows a scale change of 20×.

The entire surface of the displayed artifact can be surveyed by this method to locate hot spots in the lighting. The instrument allows the adjustment of light intensity for even lighting distributions across the entire surface of the photograph.

Supplier:
 Gossen Panlux Luxmeter Local photographic equipment supplier.

Crawford UV Monitor 760

This instrument provides a direct measurement of the ultraviolet content of the light hitting the sensors. The application involves placing the sensors, which are located on the top of the monitor, in front of the photograph in such a way that the light hitting the monitor emulates the light hitting the photograph (see Figure 5.3).

The measuring button is depressed to activate the operation and the adjustable dial on the face of the instrument is turned back and forth until the two red lights on the face of the monitor alternately flash back and forth. The reading is an

approximate one because the scale is not delineated very clearly, but the desired value of less than 75 microwatts/lumen is easily determined from the scale.

The operating instructions are clearly described on the back of the instrument and the limiting value is also listed there.

Supplier:
 Crawford UV Monitor 760 Science Associates

Biological Infestation

UVGL Mineralight Lamp

This is a lamp housing two different ultraviolet sources, which provide either a short or a long wavelength. The viewing of an infested photograph with these allows the determination and detection of active biological infestations of mold and fungus. The use of the short wavelength lamp must include protective goggles to prevent damage from this radiation. Do not look at this light source without wearing protective goggles (Figure 5.4).

The active sites of biological infestation will fluoresce and the degree of infestation and the areas of infestation will be clearly evident under ultraviolet light. This same lamp can also be used to help delineate faded iron-gall ink.

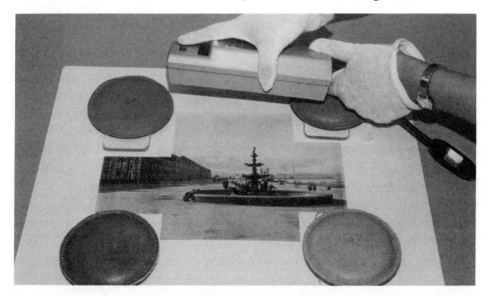

Fig. 5.4 The UV lamp is used in subdued light and is held over the object, close to its surface. The fluorescence, if present, will be visible as a lighter color or area.

Suppliers:

UVGL Mineralight Lamp	VWR Scientific
Spectroline Short/Longwave	Fisher Scientific
Ultra Violet Safety Glasses	Safety Supply Co.
UV Absorbing Goggles	Fisher Scientific

EXHIBITION ENVIRONMENTS FOR PHOTOGRAPHS

The pressure to exhibit the best, the most representative example, or the best-known example is a pressure we all have to come to terms with in exhibition policy. The decision to exhibit, reached after discussion with the various professionals involved, should then be designed to provide the best preparation and protection possible for the photograph during the exhibition period.

The choice and selection process is controlled primarily by the curator or researcher and as a rule is examined by the conservator after preliminary selections have been made. The preliminary condition report provides the documentation on which rejection and acceptance criteria can be discussed by all parties. Often a chosen print is replaced with an alternative item because of conservation considerations.

Monitoring Prints on Exhibition

The monitoring of photographic images, particularly ones being exhibited, is becoming a standard practice. This includes the pre- and post-treatment steps of the conservation and preservation activities as well as exhibition and display periods. In situations such as these the artifacts are monitored densitometrically and in special cases the application might include a UV/VIS spectrophotometer, for both color and density changes, shifts, and losses.

The photograph is measured after matting by defining the measured areas with a Mylar overlay from which the measuring hole is cut out and removed. Changes in values measured during the exhibition in excess of the error associated with the densitometer (or measuring instrument) define a change in the artifact due to the exhibition environment. Consideration of its removal from the exhibition should be discussed. In most applications the measurements are not taken during the exhibition, but rather after the exhibition is returned from loan. In situations where sensitive materials are involved and changes are suspected, they should be monitored during the exhibition.

Densitometers are specialized instruments found in photographic and conser-

vation laboratories. The most versatile instrument is the MacBeth TR 924, transmission and reflectance densitometer. This instrument provides an indication of the changes an artifact has undergone by measuring the density and color of the artifact. Problems associated with this instrument include the fact that the filters used in the instrument are subject to some change over time and with use. This calls into question the instrument's accuracy in long-time interval monitoring.

The immediate environment parameters of the exhibition are monitored with the instruments mentioned earlier, including continuous recording hygrothermographs, hand-held photometers, UV meters, and instruments such as the densitometers or UV/VIS spectrophotometers. The exhibition of materials in spaces outside of the collection calls for preliminary security reports to be completed by the borrowing institutions, with the understanding that the exhibition must be displayed in a defined and controlled environment.

The popularity of some images will necessitate the generation of an exhibition history of all items that are exhibited to insure that an item is not loaned and exhibited repeatedly. The practice in many collections is to restrict the number of times an item is exhibited to a maximum of four occasions. Photographs cannot be placed "on permanent exhibition." The use of this term by professionals responsible for the security and preservation of photographic artifacts is inconsistent with the abilities of most photographic media to survive extended display periods.

RECOMMENDED ENVIRONMENTAL VALUES FOR EXHIBITION AND DISPLAY

The conditions of display and exhibition are generally defined as follows:

1. the display space must have climate control
2. the temperature target value is 68°F, ±2° range
3. the relative humidity target value is 50 percent, ±4 percent range, preferably without cycling
4. the light levels are not to exceed 50 lux or 5 footcandles
5. the ultraviolet component of the light must not exceed 75 microwatts per lumen

There may also be specific procedures and restrictions placed on some materials because of their inherent sensitivity to exhibition. One such procedure for some of the early types of photography, as well as contemporary color materials, is

the use of covered display cases which provide viewing light only when requested. In situations where an on-demand lighting system is not possible, a dark, hanging cloth can be used. Viewing requires the removal of the cover cloth. For most photographs the use of an ultraviolet absorbing glazing will help minimize light damage.

Display Environment Summary Table

LIGHTincandescent, 50 lux (5 footcandles) or less,
UV component less than 75 microwatts per lumen

RELATIVE
HUMIDITY........50 percent, +/− 4 percent range, minimal cycling acceptable
40 percent, +/− 4 percent range, minimal cycling preferred

TEMPERATURE ...68°F, +/− 2°F range, minimal cycling acceptable

AIR QUALITYfiltered for particulates as well as chemically
active gases, both return and replacement air.

LOAN ENVIRONMENTS

In-house exhibitions often travel, and in situations where more than one location is on the venue, preliminary security reports must be completed by all institutions and galleries that will receive the exhibition. As a rule the number of exhibition stops and the time on loan in any one place is limited to a maximum of three consecutive stops and a maximum of three months per location during any single circuit. The sensitive artifacts within a show might be rotated with other representative images after each exhibition location, thus reducing the impact on any single print being shown.

The conditions maintained during shipment from location to location must include considerations of packing and unpacking instructions, packing diagrams for the crates, and condition reports for each stop. The crates must be constructed from inert materials to insure that there is no chemical interaction of the packing materials with the photographs; the crate itself must be strong enough to provide the physical protection required; the crate must be isolated from the external shipping environment.

STORAGE ENVIRONMENTS

Storage environments as a rule are among the most controlled of all the areas in which photographs are kept. As such, they may have reduced considerations

involving light and light intensity. These areas must be concerned with all of the environmental factors, particularly air quality. The presence of nitrate-based materials or inappropriate packing materials that emit oxidative gases can be a greater threat to the photograph than any of the other environment parameters.

The storage of photographs and collections can now be classified in one of three different environmental applications: ambient, cool and cold. The ambient storage environment—the museum, library or archive norm—is the case we are most familiar with. This condition is the most common one and is in general appropriate for most photographic materials.

The problems associated with a number of chemically sensitive, rapidly deteriorating photographic processes have resulted in the development of cold storage environments for the long-term stabilization of these materials. The use of cold rooms for the storage of contemporary color photographs and the use of low-temperature conditions for cellulose nitrate collections have now become considerations in many collections. Access to materials such as these is severely restricted and thus the third environment has been evolved, the cool storage environment.

The concept behind the use of a cool storage environment is the need to drop temperatures and relative humidities to reduce and retard the rate of deterioration of photographic collection materials while still making them available to staff and patrons in a timely fashion. The conditions of the cool room must be correlated very closely with the operating, ambient environmental conditions in the patron access area to insure that the paged photographs do not cross a dew point. The application of cool and cold storage environments may have implications for the artifact in terms of dimensional stresses which the photograph undergoes, since this application represents a form of cycling.

The presence of housecleaning chemicals, particularly domestic cleaning solutions, can also be a problem. Ammonia, a major component of common cleaning solutions, can result in chemical interactions with silver-based image materials. The presence of liquids in the storage environment in general is a hazard and cannot be allowed since damage by liquid penetration often results in irreversible damage to the photograph. The use of cleaning chemicals must be reviewed before use in collection areas.

The use of quality materials in the storage of the collection materials is discussed in other chapters of this book. The application of these materials throughout the storage areas will insure minimal deterioration.

Storage Environment Summary Table

LIGHTshielded or low UV fluorescent or incandescent, values
to a maximum of 80 lux (8 to 10 footcandles), lower preferred
UV component less than 75 microwatts per lumen

RELATIVE
HUMIDITY........40 percent, $+/-$ 4 percent range, minimal cycling acceptable
30 percent, $+/-$ 4 percent range, minimal cycling preferred

TEMPERATURE ...ambient vault, 60°F, $+/-$ 2°F range, minimal cycling
cool vault, 50°F, $+/-$ 2°F range, minimal cycling
cold vault, 40°F, $+/-$ 2°F range, minimal cycling

AIR QUALITYfiltered for particulates as well as chemically
active gases, both return and replacement air

*Remember that these temperatures are interrelated because the artifacts will be moving back and forth from one environment to the other. These temperatures are also guides for reasonable applications; the temperatures used could be much lower.

PATRON/STAFF USE ENVIRONMENT

The patron and staff use environment is similar to the exhibition environment considerations. The space must be clean and well lit. There must be large table surface areas to allow materials to be laid out for observation without artifacts and housings being placed on top of one another.

The use of light levels in excess of the 50 lux exhibition level is required for visibility and to allow patrons to detect and resolve the finer details in the artifact during examination. These brighter conditions can be offset by controlling the number of items under examination at any given time and by minimizing the duration of exposure of these photographs to the elevated light levels.

The period of time the artifact is exposed to the brighter conditions is relatively short when compared to an exhibition exposure under lower light intensities. This is not to say that short exposures to high-intensity light are the same as long

exposure to low-intensity light. The reactions taking place for any given photo-graph may vary.

The use of a stereo microscope for examination and a fiber optic light source during examination would also be helpful, since these instruments would insure that general light levels could be reduced while still assisting the patron with the detailed examination of the artifact.

The most constructive measures for the patron-use environment are the isolation and control of the handling to which the artifact is subjected. If this is not possible the photograph should be placed in a housing that will maximize its protection while still allowing it to be viewed. The removal of delicate, friable, or sensitive materials from general use may be necessary. As a rule, access to these will be on a case-by-case basis, and a conservation treatment for the piece may be applied before it is reintroduced for patron use.

Of the different environments an artifact will be exposed to, the most damaging by far is the patron or user environment. Physical damage because of the popularity of an image, particularly images chosen by educators for use as support materials for a semester course, is the worst case. The preparation of this material, the instruction of patrons on proper handling, and the identification of the idiosyn-crasies of the varied types of housings found in the collection are the most constructive ways of overcoming these problems. The use of a slide/tape pre-sentation for newcomers to the collection, both staff and researchers, and a release signed by the patron are two policing methods.

Special aids to researchers and patrons are designed to minimize damage and include structures to free the researchers' hands for note taking as well as the use of appropriate housings in the preservation program to insure protection of the photograph during use. The accessories that help the researcher in an immediate way include items such as book snakes and book cradles. These two accessories allow the bound album to be laid down, open to the page of interest without requiring the researcher to hold the book.

In the case of single sheets, pages, and prints, a matting or folder-style housing should be chosen which also matches the end use of that artifact. This should include the sling matt style for thin, unmounted materials and sink matts for mounted materials.

Patron/Staff Use Environment Summary Table

LIGHTshielded or low UV fluorescent
daylight color balance to a maximum of
80 lux (8 to 10 footcandles),
lower preferred
UV component less than 75 microwatts per lumen

RELATIVE
HUMIDITY........40 percent, +/− 4 percent range, minimal cycling *acceptable*
30 percent, +/− 4 percent range, minimal cycling *preferred*

TEMPERATURE ...68°F, +/− 2°F range, minimal cycling

AIR QUALITYfiltered for particulates as well as chemically
active gases, both return and replacement air

6

Housing Photographs

QUALITY OF MATERIALS

The quality of the materials used for the storage of processed photographic materials is as important as the quality of materials used with the unexposed sensitized product. The single most common component material used in the housing of photographs is made of paper or paperboard. Plastics are also finding increased use in the contemporary marketplace and in many cases are the most convenient product for use with collections of materials.

Paper Products

The requirements for paper and paperboard products are our first concern because of their preferred use with historic collection materials. In general, paper that is intended for use in the storage of photographic collections should have a quality fiber composition and be processed to levels with minimal residual chemicals. In particular the presence of processing chemicals that include sulfur and sulfur compounds must be avoided. The paper industry uses thiosulfates for neutralization of chlorine bleaching compounds, and both of these must be eliminated from the paper. Residual oxidizing chemicals must also be eliminated from the finished paper product.

The present use of cellulose derived from wood can result in amounts of noncellulosic materials present in the finished paper product. These unprocessed raw and partially processed materials must be eliminated from papers to be used with photographs. The presence of lignin as a residual, noncellulosic component results in deterioration of the photographic artifact by organic acid attack; oxidizing gases such as peroxides result in image alteration. These partially processed

125

papers and paper boards are found in common cardboard and kraft papers.

The use of wood-derived cellulose should not be viewed as undesirable. The proper processing of this material to a high alpha cellulose quality of pulp results in an acceptable paper product for use with photographs. The chemical refining of the wood pulp, however, results in a paper that is not as durable as one fabricated from a high-quality cotton fiber pulp.

The shift away from traditionally used quality fibers, rags composed of cotton and flax, towards cheaper, more plentiful plant cellulose, such as wood cellulose, was well established by the twentieth century. The paper created from this source of wood plant material has poor chemical stability because of associated non-cellulosic materials. These noncellulose residues degrade and result in discoloration of the paper as well as a loss of the paper's durability and strength.

Papers made from wood cellulose sources can be refined to levels of chemical purity; the use of these types of papers is appropriate if the undesirable noncellulosic components have been eliminated in fabrication. These papers should be lignin-free and have a high alpha cellulose content. They will have additives that are designed to provide strength since the chemical processing needed to purify the fibers will also have weakened them.

In selecting a product, look for terms such as *lignin-free, high alpha cellulose, rag, conservation quality, museum quality, archival, unbuffered,* and in a few cases *buffered* or *acid-free.* These terms are used in various ways to identify quality papers and paper products. The applications of each of these to photographs will be discussed later in this chapter.

One manufacturer of paper products for use in museums, archives, and libraries, Conservation Resources International, prints the specifications for their photographic products in their catalogue and is quite exhaustive in defining the limits of the various residuals allowed in their paper products. This same catalogue contains several pages of basic paper chemistry to help explain the processes that occur when paper deteriorates.

An area of confusion during the last few years has been the controversy over the use of paper and paper products that are buffered. The general attitude is to use an unbuffered product rather than a buffered one except in situations where acidity is known to be present as an active contributing element. This situation might be a nitrate-based photograph or result from a polluted atmosphere. This approach is based on the simple fact that we are not yet familiar with the interaction of buffered papers with photographs. The situation could occur where the presence

of the buffering compound might adversely affect the photograph, particularly in direct contact. Therefore, use of unbuffered products is recommended.

There are two photographic processes that have a documented sensitivity to alkaline environments. These are the photographic blueprint or cyanotype process and the contemporary dye transfer process. These artifacts will discolor if brought into contact with alkaline materials or solutions. There may also be other cases yet to be resolved that involve slow chemical reaction processes which we are not yet aware of and which may not be apparent until the damage has occurred and has been documented.

The use of buffering compounds in paper products and as a treatment step for paper artifacts is based on a well-established deterioration process. The long-term chemical stability of paper is enhanced by a buffered, alkaline environment. The trend in paper is for the deterioration products to be acidic in value. These acidic decomposition products increase the rate of deterioration of the paper cellulose if left unattended. This deterioration process is accelerated when associated with high relative humidity and high temperature environments and is greatly increased in situations that include noncellulosic components in the paper furnish, particularly lignin.

The addition of a carbonate compound to the paper during fabrication provides a buffer against the evolution of acidic decomposition products as they are generated during natural deterioration. This application has also been extended to paper-based artifacts, which are treated in conservation sequences that include washing to remove water-soluble decomposition by-products as well as accumulated acids. The paper is then immersed in a buffering bath, a solution of a carbonate, and deposited into the sheet; this provides an alkaline reserve against the future build-up of acidic decomposition products.

Photographs should not be treated with alkaline buffering compounds. All treatments of this sort should be implemented only by a person familiar with the options available and the ethics associated with these treatments.

The use of buffered paper products with photographic materials is limited to cases where the photographs emit acids or become acidic with time to such a degree that the security of the piece is in question. The situation exemplified by cellulose nitrate based materials is such a case. Also, in uncontrolled environments in which acidic gases are present, the use of buffered paper products should also be considered. Associated materials or secondary supports for the artifact that are acidic (for example, a mounted photograph on an acidic board), are other

examples where the use of buffered materials should be considered.

The last topic for our discussion of paper products is an examination of CRI's lignin-free Types I and II, and what their applications should be. The Type I is similar to other manufactured lignin-free paper products, and its application would be standard. The Type II product, however, differs in that it has a polyester isolation sheet sandwiched between a buffered lignin-free board and a sheet of unbuffered paper. The unbuffered paper is on the inside or artifact side, while the buffered board is on the outside.

The barrier that this creates can be very effective if applied correctly. The Type II product should be used in situations where it is desirable to keep hostile elements out or needed elements in. The probability of collection materials being wetted or damaged from atmospheric pollutants would indicate that the barrier would be helpful in retarding the access of these elements into the box. The storage of diacetate materials would be appropriate since the plasticizer that is escaping needs to be kept in the immediate environment. Cellulose nitrate should not be kept in a Type II box since the decomposition products from this type of artifact must not be allowed to accumulate.

In general, Type I products should be used with historic artifacts that are likely to have been fabricated with residual chemicals as a component of the photograph; the accumulation of decomposition by-products from these should be allowed to dissipate. The Type II product is best for use with contemporary materials where the quality of fabrication and processing is known to be high and where the external environment is bound to be detrimental.

Plastic Products

The use of plastics for the storage of photographs is widespread in both the amateur and professional photographic fields. The problems with these commercial plastic products can include the plastic itself, often a polyvinyl chloride, a low-quality plastic inappropriate for use with photographic materials. The presence of plasticizers that may have been used in the plastics and that often diffuse out onto the photograph stored within them is another problem that occurs with many plastics. The last major consideration is the presence of residual chemicals from the fabrication process, including catalysts and primary constituents not consumed in the reaction process.

The single most common plastic for use with photographic materials, particularly in the form of slide pages for 35mm color transparencies, is polyvinyl chloride or PVC. This product is not safe for use with photographs if their long-

term chemical stability is to be insured. The plastic deteriorates to form a strong acid, and in general has been observed to extrude plasticizers and other chemicals used in the fabrication of this plastic.

The plastics which are being used in the preservation of photographic materials and which are safe to use include polyester (Mylar D or Melinex 516), polyethylene, cellulose triacetate, polypropylene, and polycarbonate. These plastics come in many grades and have associated end-use additives which can negate their use in collections. The purchase of polyester must include the specification that the particular product be Mylar Type D (DuPont) or Melinex 516 (ICI). All of the above plastics are found and used in various configurations, including sleeves and slide pages.

The availability of different grades of plastic is compounded by the difficulty of identifying the quality of a plastic product without the use of chemical analytical methods. It is because of this difficulty that the type of plastic products recommended by various conservators should be specified and not substituted. It is easier to supply a recommended plastic product than to take an unknown and analyze it for composition and application. Specific recommendations have been given in this book whenever possible.

The use of polyethylene and polyester for sleeves is common. Polyester is stronger and so less forgiving under stressed environments. Polyethylene is softer and scratches more easily; after extensive scratching it may lose its transparency and become milky. Polyester tends to be electrostatic, attracting dirt and dust which could damage the artifact during removal. The advantage of polyethylene over most plastics is that it can be fabricated with minimal use of plasticizers and catalysts.

The use of polyester, polyethylene, or cellulose triacetate is appropriate for sleeving photographic materials. But beware of frosted plastics, particularly those made of polyester. There are some frosted sleeves that have had an abrasive coated onto one surface. These sleeves can abrade the emulsions of artifacts being slid in and out of them. A simple test is to take a piece of black film (unexposed reversal film) and gently rub the emulsion side back and forth on the frosted surface. The surface will show scratches in the direction of rubbing if an abrasive frosting has been used.

Metal Products

The use of metal is usually found in shelving and horizontal drawers and is commonplace in collection storage areas. The use of uncoated or raw metal is

unacceptable. The best kinds of metal drawers and shelving are ones that have been painted with a baked enamel paint that has cured prior to use in the collection.

The use of lubricants on the drawers should be limited to silicon-based products and it may be necessary to wipe and clean the tracks of new units to remove all of the greasy lubricant applied by the manufacturer before placing photographs into the drawers. This lubricant will dry and begin to drop off the rails, into the drawers, and onto the photographs. Housekeeping tasks for the metal drawers and shelving include regular vacuuming of the drawer interiors and minimal application of the silicon lubricant.

The application and use of metal for storage usually does not extend to smaller units or boxes. The cost and weight have in fact resulted in one such product, a metal storage tray for matted photographic prints, soon to be abandoned by the manufacturer. The one application that continues to be made in metal boxes is the slide storage unit for 2″ × 2″ color transparencies.

Undesirable Products and Components

Many products are inappropriate for use with photographic collections. The following items, groups of materials, and chemicals have been identified and must be excluded from the collection environment if optimal conditions are to be maintained.

Sulfur-based chemicals and materials including:
 rubber cement
 elastic (rubber) bands
 sulfite and kraft papers
 industrial pollutants

Chlorine-based chemicals and materials including:
 polyvinyl chloride plastics
 cleaners and commercial cleaning solutions
 sweat and perspiration salts transferred by people

Oxidizing gases and chemicals including:
 ozone from xerox or electrostatic copiers
 industrial atmospheric pollutants
 ammonia, particularly from household cleaners
 cellulose nitrate-based photographs

oil-based paints
floor varnishes
wood and lignified materials

Organic acids and basic chemicals and materials including:
wood and lignified materials
sulfite and kraft papers
glassine, including the neutral grade
cardboard and unprocessed paper products, including old photographic
 product boxes
pressure-sensitive tapes

Iron-based metal products including:
paper clips

These are the most notorious problem materials that generally react with the photographic image, binder, or support. They will contribute to the deterioration of photographs. One way to minimize the impact these materials might have on a collection is to eliminate them from collection areas. The control of the photograph's environment is another, and the use of an appropriate intimate housing will be examined next.

Intimate Housings
An intimate housing is a material or product of high quality which contacts the photograph directly, as opposed to the common and larger unit where the photograph in its intimate housing is stored. This direct contact is the first form of protection, one requiring high quality components.

Matts
The most common housing for a photograph is the matt. The quality of the matt board used should be unbuffered, rag (although a high alpha-cellulose board is acceptable), in 4- and 6-ply thicknesses. The use of matts in most collections is associated with standard sizes and these have become somewhat common throughout the field, so much so that the various products for matting are cut to these standard sizes by suppliers.

The following table lists some of the standard sizes in use by photographers and museums. They are supplied by various firms:

Photography	Fine Art	Suppliers
8×10		8×10
11×14		11×14
	14×18	14×18
16×20	16×20	16×20
		16×22
20×24	20×24	20×24
	22×28	22×28
		22×30
		24×30
	28×40	
		32×40

The construction details for a number of museum-style matts are presented in the Library of Congress publication *Matting and Hinging of Works of Art on Paper* by Merrily Smith and Margaret Brown. The following discussion is designed to complement this text.

Matt Styles

The Library of Congress matting and hinging publication is designed for works of art on paper and is applicable to photographic prints with little or no modification. The following discussion and minor construction modifications should allow these styles to be adapted to photographs.

The standard matt and the normal hinging styles are described in several publications including the Library of Congress guide. The basic configuration is illustrated in Figure 6.1. The window or cover matt is attached to the back matt with linen tape along the long side, opening like a book. The photograph is centered and hinged to a 2-ply matt board using a paper hinge of Japanese paper adhered with a wheat starch adhesive. This 2-ply board is then hinged to the back board of the matt using linen tape.

The standard matt and matt window include both encroach windows and float windows. An encroaching window is laid over the artifact, and requires a non-image edge area to be present. The encroaching of a photographic image is not recommended because of a differential rate of discoloration and density loss between the covered and uncovered portions of the image. The use of a float is required in situations where the matted photograph has been cut flush to the image (Figure 6.2).

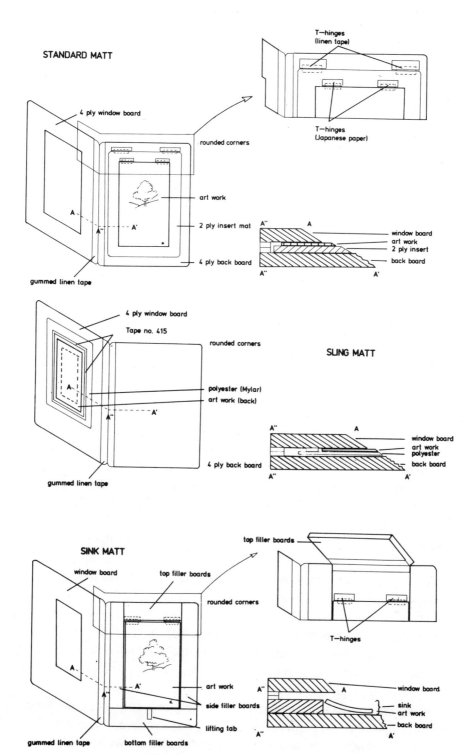

Fig. 6.1 These three diagrams illustrate the most common matting styles used with photographic materials.

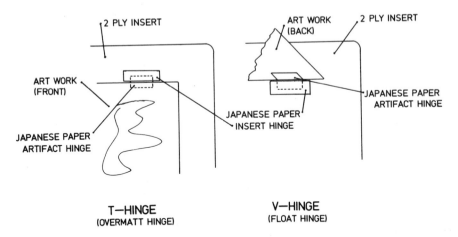

T—HINGE
(OVERMATT HINGE)

V—HINGE
(FLOAT HINGE)

Fig. 6.2 The T-hinge and the V-hinge provide hinging for prints. The T can be used in situations where the matt window covers the hinge and therefore a portion of the photograph's mount. The V is used in situations where the hinge can not be covered by the matt window and therefore the hinge must be hidden. Remember that the photographic image should not be overmatted (covered by the window matt).

The float matt has a matt window that is larger than the photograph and which does not touch the photograph. In this configuration the entire edge of the artifact is visible and it becomes necessary to use a "V" hinge style rather than the conventional "T".

The sling matt makes use of an attachment system which does not require hinging of the photograph. This style of matt is ideal for contemporary photographic prints which have large, nonimage edge areas. The sling works on the basis of trapping a portion of the nonimage edge area of the photograph against the matt window. Figure 6.1 shows the construction detail of this matt. Photographic prints which have been cut flush cannot be matted in this style of matt without being inlaid into another sheet of paper.

The sink matt is the most common matting style for mounted photographs and particularly items mounted on brittle, acidic boards. This style of matt creates a sink around the mounted print to insure that the window of the matt will not rest on the photograph and to make up the difference in thickness of the mount so that the photograph and mount will not be stressed when picked up or handled. It may also be necessary to provide a Mylar gutter strip along the bottom edge of the mounted photograph to support the print and mount should the hinges fail due to the weight of the assembly. Figure 6.1 also shows the sink matt.

The bulk of items to be matted and framed will be housed adequately in standard matts. One exception to this will be unmounted, flush-cut prints which must be displayed. Since photographic images are never overmatted and there is no non-image edge area, an inlay can be used. In other words the photographic image is always seen in its entirety even when the matt window is down and closed. In the case of an albumen print, the curl of the loose print can be quite pronounced and the print cannot be held in place.

The appropriate approach in this situation is to have the albumen print inlaid into another piece of quality paper. The inlay technique is a skilled activity involving the adhering of the print into a cut and prepared window in a sheet of paper. The print is adhered only along its very edges and is protected by the large sheet of paper it was laid into. The matt window can now be cut to fit outside the print area and all of the print can be seen without encroaching onto the photographic image. Figure 6.3 is an example of this technique.

Fig. 6.3 The inlay, when viewed by transmitted light, shows the minimal overlap by the inlay paper.

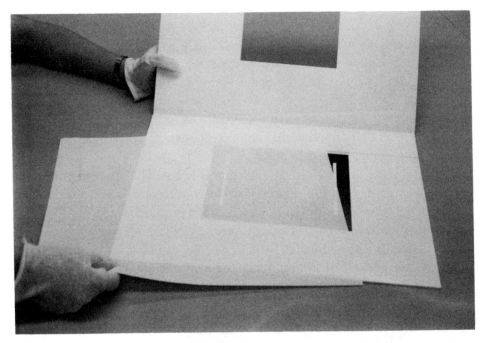

Fig. 6.4 The use of interleaving paper is important in protecting the surface of the photographic print. The intimate contact of this paper with the print requires that it be of a superior quality.

Tissue Slip Sheets (Interleaving)

Tissue slip sheets or interleaving sheets are inserted into a finished and assembled matt to provide protection to the photograph or work of art hinged into the matt. The removal of this sheet is necessary if the print is to be viewed; this additional handling can create problems if the person doing it is not familiar with the procedure. Recommendations for the use of plastic slip sheets and in particular polyester should not be used with matted photographs.

The advantage of being able to see the artifact without removal of the slip sheet causes problems with researchers and curators who do wish to examine the print's surface directly. The electrostatic nature of the polyester product can result in dirt and grit being held on the plastic sheet; abrasion of the print emulsion can occur. Collodio-chloride prints have particularly sensitive surfaces, as do all collodion binders.

The most common and most appropriate interleaving product is paper thin enough to provide some opportunity to determine the subject of the print without removal of the tissue but still thick enough to provide protection to the print surface during handling. The paper must also be of an appropriate quality in terms of fiber quality and chemical inertness.

The tissue should be cut to standard sizes less an inch on two adjacent sides, or it should be one-half inch smaller on all four sides. The sheet will fit into the matt without requiring realignment or extending out of the matt, but will be larger than the matt window, thus protecting the photograph (Figure 6.4).

The tissues which are of an acceptable quality for use as interleaving and slip sheets include the following:

Atlantis Silversafe
Conservation Resources International

40, 80 and 120 g/sq m basis weight
38 × 48 inches, sheet size

This paper is appropriate for use with all photographic artifacts.

This paper is made to the proper specifications for use with photographs. It is 100 percent cotton fiber; it is highly calendered for a smooth surface; it is neutral pH, unbuffered and free of sulfur.

Archivart Unbuffered Tissue
Process Materials Corp

9.25 g/sq m basis weight
24 × 36 inches, sheet size
50 in × 250 yds, roll size

This paper should not be used except when Silversafe cannot accommodate the size of the photograph.

This paper is also useful for interleaving photographic materials. It is made of an acceptable fiber; is unbuffered and neutral. It is not ideal, however, since the sulfur content is unknown.

Archivart Tissue
Process Materials Corp

21 g/sq m basis weight
20 × 30 inch, sheet size
40 in × 500 yds, roll size

This paper should only be used with platinum or palladium prints.

This paper is useful for interleaving photographic platinum or palladium prints. It is a quality fiber, and buffered.

The use of tissue slip sheets can be replaced by the use of a wrapper board. This solution is not always viable since it increases the cost of the matt and reduces the storage density in storage boxes. The use of interleaving tissues as slip sheets also leads to numerous other problems. Most common is the desire to have a thin tissue that is transparent enough to allow see-through without its removal. Yet because of its flimsy character it invariably folds up on itself and creases. The thicker tissues and papers are either semitransparent or opaque and require removal before viewing. This can lead to situations which cause stress to the artifact because of the careless or hurried removal of the paper during the search for a given image.

The wrapper board provides protection to the matted piece and by its size and construction requires the individual using the piece to open the matt with due care. The advantages of the wrapper outweigh the added cost and bulk and should be considered a more desirable housing structure than the matt by itself.

Matt Boards

The quality of the paper boards used in matting photographs has already been mentioned. The use of unbuffered matt boards is required for matting photographic materials. The use of a buffered board might be appropriate for use with acidic mounts or processes such as the platinotype because of the acidic transition these photographic processes deteriorate into. The fiber quality should be 100 percent cotton or rag, although the less expensive high alpha cellulose product can also be used. Remember that the terms *buffered* and *acid-free* are used to describe matt boards that are buffered. The following table lists the various manufacturers of quality matt board products.

The terms *museum quality* and *conservation quality* are also used to describe matt boards and the manufacturer's description should be used to distinguish between the different products; one will be a rag, the other a high alpha cellulose. In both cases the unbuffered product should be employed.

The use of lignin-free boards and other board products will be discussed in a section on the construction of custom-built housings. These board products are not used for matts.

Sleeves, Enclosures and Envelopes

The last set of housings to be discussed are the paper envelopes, plastic sleeves, and paper enclosures. The ideal storage format for negatives and film materials is a paper enclosure with either a three- or four-flap construction. The four-flap

	MATT BOARDS	
Products (Type)	**Advantages**	**Suppliers**
Cotton (Rag), 100 percent Unbuffered	The high quality fiber used in this type of product provides a very stable storage environment. The unbuffered state is appropriate for use with all photographs.	Light Impressions Corp. Non-buffered 100 percent Rag Board Process Materials Corp. Archivart Photographic Board
Cotton (Rag), 100 percent Buffered	This buffered product should be used with platinum and palladium prints only.	Light Impressions Corp. Westminster 100 percent Rag Board Process Materials Corp. Archivart Museum Board
Alpha Cellulose, Unbuffered	This unbuffered, high alpha cellulose board is also low in sulfur and lignin-free for use with all photographs. It is less durable than the 100 percent rag product, but it is also less expensive.	Conservation Resources International Photographic Matt Mounting Board

construction provides maximum protection of the contents. It requires the viewer to place the enclosure down on a flat surface to open and thus insures that the artifact is not dropped during removal, an important consideration for glass plates. Another advantage of both the three- and four-flap enclosures is the fact that the glass plate's thickness can be accommodated by adding a second set of creases to the enclosure flaps.

The use of paper envelopes is still prevalent. One reason for this may be the cost difference between the envelope and the enclosure products. The presence of join seams and adhesives to hold these in place in the construction configuration of the envelope prevents it from being an appropriate storage container for photographs. The multiple layers caused by the presence of the seam can result in physical deformation of the photograph contained within the envelope, particularly those with gelatin emulsion layers. The use of adhesives on the seam, particularly water-sensitive (hygroscopic) adhesives, can result in local accelerated chemical deterioration along the seam line. The last point is that the envelope requires the

photograph to be pulled out of the container and to be shoved back in. This can result in mechanical damage to items with blistered emulsions.

The four-flap enclosure is the most appropriate storage form for negatives and positives on glass and plastic supports in historic or archive collections to which access is limited. The use of plastic sleeves is more appropriate for use in an active collection and in situations when the artifact is accessed on a regular basis. The ability to examine the image without having to remove it is the ideal situation, since the enclosure would require more handling of the artifact during use.

The availability of frosted or matt plastic sleeves raises two questions concerning their use for the storage of photographic images. The first is whether the frosting is due to a surface application of an inert chemical compound. The second is whether the use of a matt or frosted surface actually assists or hinders viewing of the contents. We have already discussed the problem of scratching the artifact with frosted plastic sleeves that have a surface deposit of an inorganic pigment on them.

The other aspect of this question is the need for a frosted sleeve. The frosted layer assists in the general viewing of the contents but interferes with the ability to resolve the sharpness of the image even with a magnifier or loop. The use of a clear plastic sleeve resolves both the problem of the abrasion of the artifact as well as the resolution of the image sharpness and as such is the preferred storage format.

TYVEK, a random spun polyethylene, is available from a number of distributors in forms useful for photographic artifact storage. Tyvek envelopes and sleeves are opaque and cost considerably more than comparable photographic grade paper products and are safe for use with photographic artifacts.

Plastic sleeves are available in a large number of sizes and formats and also in a wide range of plastics. The listing of manufacturers and products at the end of this section should provide the variety of choice in paper and plastic storage formats necessary for your collection materials.

Cold storage envelopes, composed of an aluminum foil, polyethylene and paper laminate structure, are used for the storage of artifacts in low-temperature storage systems. The artifacts must be conditioned and packaged in low relative humidity conditions prior to sealing and storing at depressed temperatures. This storage technique has gained considerable application with contemporary color materials and to a lesser degree with cellulose nitrate based films.

The use of a paper enclosure is appropriate for historic and archival collection materials; plastic sleeves are appropriate for use in active collections. The old-

style, conventional paper envelope still being sold by suppliers should not be used but replaced with one of the other two storage forms.

Enclosures

PAPER STORAGE ENCLOSURES FLAP STYLE ALPHA CELLULOSE COMPOSITION UNBUFFERED

This type of enclosure is available in two configurations, a three-flap and a four-flap construction. The four-flap is a safer construction and is the ideal choice. These enclosures are also low in sulfur.

—Negatives, both glass and plastic can be housed in these

—Enclosures for glass include a second set of score lines to account for the glass thickness

Suppliers: 1. Conservation Resoures International
Four-Flap Negative Envelopes
2. Process Materials Corp.
Archivart Photographic Negative Enclosures
3. Light Impressions Corp.
Seamless Envelopes and Glass Plate Folders

PAPER STORAGE ENCLOSURES FLAP STYLE ALPHA CELLULOSE COMPOSITION BUFFERED

This four-flap enclosure is designed specifically for use with cellulose nitrate plastic support materials. This buffered enclosure will engage the acidic decomposition products generated by the cellulose nitrate.

—Cellulose nitrate plastic-based artifacts only

Suppliers: 1. Conservation Resources International
Four-Flap Buffered Negative Envelopes

PLASTIC STORAGE SHEET STYLE POLYETHYLENE COMPOSITION SLEEVES

These plastic sleeves are ideal for active collections that are being printed and accessed regularly. The quality of the plastic is appropriate for use with plastic-based artifacts other than cellulose nitrate. The ideal application is with contemporary plastic artifact collections.

—All plastic-based artifacts except cellulose nitrate

Suppliers: 1. Light Impressions Corp.
Print File Preservers

PLASTIC STORAGE SHEET STYLE POLYESTER COMPOSITION

These plastic sleeves are also appropriate for use in active collections but they are subject to electrostatic charging. Dirt and grit can be held by the sleeve and in some situations increase the possibility of damaging the binder.

—All plastic-based artifacts except cellulose nitrate

Suppliers: 1. Conservation Resources International
Polyester Negative Sleeves
2. Light Impressions Corp.
Fold*Lock Sleeves

Storage Systems

There are several systems presently available that make use of some of the elements we have discussed to this point. The integration of these different components into a usable package is useful in some storage models and can be particularly helpful in contemporary collections.

The basic system is a sleeve or enclosure that in turn is filed in a box. The two most common box styles will now be discussed.

The Light Impression Corp. provides a system called Nega*Guard. This system is designed to house negatives in the more common, contemporary formats. The box is made from their Flip*Top line of side-opening, lignin-free board. The

sleeves are polyester (Mylar), with the Fold*Lock closing mechanism. After being placed into the sleeve, the negative is inserted into an Interleaving Folder and boxed. The system accommodates Thumb-Cut Envelopes for the larger format negatives (Figure 6.5).

This system has several options which should not be chosen for the optimal storage and use of a negative collection. The Fold*Lock sleeves used in the smaller formats fold over and could emboss onto the negative, particularly if the box is packed full. The system also utilizes Thumb-Cut Envelopes for the larger formats, and envelopes are not a desirable housing form.

Conservation Resources International also provides a system composed of various products. One is a plastic sleeve of polypropylene which holds the photograph. This polypropylene sleeve is inserted into a folder, which is then housed in a side-opening box made from quality materials. The general design is similar to the other types of product available from other manufacturers (Figure 6.5).

Fig. 6.5 Two storage systems most appropriate for contemporary photographers and for small format collections. The set on the left is available from Light Impressions and the set on the right from Conservation Resources International. The advantage of the CRI box lies in the internal divider which prevents the sleeve folders from falling over when the box is only partly full. The CRI box is also balanced in such a way that the box does not tip over when the lid is opened back.

The notable differences between these two product lines occurs in the CRI Lig-free II* boxes, which have an internal, expandable compartment adjustment and a lower center of gravity that prevents the box from falling over when the top is left open on a partially filled box. The box is also a heavier caliper and is not crushed in handling and use and the box lid closes snugly even after it has been broken in.

The application of the Lig-free II* paperboard in this box is worth discussing. The internal lamination of the board includes a vapor barrier of polyester which aids in minimizing the penetration of external pollutants and oxidizing gases. The use of this material with contemporary photographic collections that have been properly processed to archival standards will insure the preservation of the film contents.

Albums

Photographic albums represent a storage system of a sort, particularly for prints. The configurations of albums we see in historic collections are extremely varied. The style was often designed on the basis of the format, the process, or the mounting style used. These albums all had their particular problems as well, but a few examples of successful album designs did evolve.

The particularly interesting aspect of this is that the problem still exists for us today. The albums available commercially are fabricated from materials of poor quality and make use of storage configurations which cannot protect the photographs kept within them. The selection of archival albums now available is growing rapidly, but they appear to be emulating the styles of some of the unsuccessful nineteenth-century examples.

The configuration most sympathetic to the storage of photographic prints is a handbound book form that has included a spacer guard as part of the bound structure and that is designed to accommodate expansion due to the addition of paper-based prints. These albums must be constructed to accommodate the features of the prints to be mounted in them, including format and weight.

The three-ring binder series is a functional storage format, but the protection afforded to the images is reduced from that of the bound album. The binders open up more easily and allow clear viewing of the mounted prints. But the production of a truly functional and structurally safe album has yet to be marketed commercially. There are numerous styles of innovative album design that are being produced by hand bookbinders.

Associated Housing

The term *associated housings* is used to describe the structurally rigid container into which the photograph and its intimate housing are placed to provide physical security. The intimate housing, being directly in contact with the artifact, provides a chemically stable environment with only limited physical protection. The structural or physical protection is provided by the use of a box or container constructed of high-quality materials that are also durable and which can provide physical safety to larger units of materials as well as single items.

Boxes

There is a wide range of prefabricated boxes available for housing and preservation programs. There are also instructions available for rare-book box styles which can be constructed by hand; these also have application with photographic materials. The Library of Congress box-making manual is the primary source for these types of handmade box constructions.

The prefabricated box selection is extensive, and the primary suppliers of these products are listed in the table at the end of this section. The conventional horizontal print boxes are available in standard sizes that correspond to the standard size matts discussed earlier. There are also vertical document boxes available for use with photographic formats. Also available are some styles of collapsible, flat print boxes.

These print and document storage boxes are made of paper and paperboard composition. The use of other materials has been limited to a metal case and tray construction which provides a strong shell. Its cost compared to the paper and paperboard products led to its discontinuation. The paperboard products provide a stable environment for the contained materials in normal handling situations.

The specifications of these boxes should include the following: a lignin-free, high alpha cellulose, buffered board stock that is free of lignified cores and kraft pulp components. The use of a cotton or "rag" quality of fiber furnish is also appropriate but the expense is unnecessary, since many of the housings come into only secondary contact with the artifact. The quality of the other board products is acceptable.

There is a product on the market, a gray box with a lignified core, which must *not* be used for the storage of photographic materials. The manufacturer of this product has attempted to solve the problem of using a kraft-type pulp core by using a buffered liner on the inside of the box. The fact remains that the lignified

core will produce gaseous peroxides that can attack the photographic artifacts contained within the box.

Vertical document storage boxes can be used for materials in smaller formats. The boxes for sheet film materials and smaller format prints tend to be in vertical boxes because of storage space considerations. Prints greater in size than 5×7 and mounted prints as well as glass plate materials are kept in horizontal print or negative storage boxes.

Framing

The use of wooden molding for the display and exhibition of photographic materials should be discouraged since wood by-products, such as unprocessed ground wood pulp or partially refined kraft pulps, emit acids and peroxides that can adversely affect the photographic image. Oak is particularly bad and should never be used for the storage of photographic collection materials.

Aluminum section frames are chemically inert and are ideal for use in framing photographs. The style and colors available are extensive and the frames are relatively inexpensive. The reuse of the frames is also possible, although it may be necessary to touch up scratches and abrasions on the frame before reusing.

While aluminum section frames are appropriate for use with contemporary photographic images, they lack aesthetic appeal for exhibitions using historic materials. In situations like this the use of a hardwood frame (other than oak) can be considered if the frame is first sealed with an acrylic varnish or vapor barrier laminate. Remember to let the varnish cure and dry completely before framing the photograph. This recommendation is not an endorsement for framing photographic images in wood. It represents a short-term solution for situations where it is absolutely essential to use a wooden frame.

The use of glass glazing should be discontinued except when the photograph has a sensitive binder, such as crayon photographs or photo-pastel prints. The use of lighter acrylic sheets with incorporated ultraviolet absorbers will reduce light damage and insure that the framed materials are not damaged by the glass, if it breaks. The disadvantage of Plexiglas is the higher cost and the fact that it scratches easily.

Housing Configurations

Small Formats

The use of vertical boxes for smaller formats is appropriate. The criterion for use is that the weight of the photograph be such that it will not sag under its own

weight or if rigid or heavy will not be damaged if it falls to a horizontal position. These storage units allow for maximum storage density, simple cataloguing and easy access. Large-format materials and pieces that are heavy or brittle require horizontal storage to prevent damage during handling and retrieval of collection materials from the storage environment.

The following qualify for vertical storage boxes:

sheet film and plastic supports to 5×7 in size

loose prints to 8×10 in size

mounted prints to 8×10 in size

Any other configuration should be housed in horizontal storage boxes.

The typical configuration within a package would be a number of photographs, each in its own paper enclosure, plastic sleeve, or file folder, placed into a vertical box with lignin-free or matt-board support dividers at appropriate distances. These examples are described in the next section.

Large or Oversized Formats

The most appropriate storage configuration for large, heavy, oversized artifacts is the horizontal print box. The storage density and access with horizontal formats are restricted because the boxes are stacked. The limit in any stacking arrangement is two boxes per shelf, and is best kept to a single box if possible.

The following are ideally kept in horizontal storage boxes:

1. All glass plates and lantern slides
2. Loose prints larger than 8×10
3. All matted prints
4. All mounted prints larger than 8×10

Within a print box a number of items would be stored, and the housing configurations might include matts, Mylbord-Ls, LF-Bords or paper enclosures. The construction details associated with the matts and paper enclosures were discussed earlier in this chapter. The other constructions and a number of housing approaches are discussed and illustrated in the next section.

Handmade Units

There are a number of housings which cannot be purchased premade from the manufacturers of the prefabricated boxes. These are items made in-house or contracted out to bookbinders or individuals who specialize in these types of activities. The matt is a handmade housing and the following housings are al-

ternatives to matting. The Mylbord-L and LF-Bord constructions are not as strong as the matt and do not provide the same level of physical protection; but they do provide short-term protection of the photographs and also allow all three housing styles to be stored together (Figure 6.6).

The Mylbord-L and the LF-Bord are two items that have found use in collections where matting was not an option. The instructions are outlined briefly and can also be found in the conservation literature. These particular constructions can be made by volunteers, who do not have to handle the photographs.

The Mylbord-L is a sheet of 4–ply matt board that has a sheet of polyester attached to it on two adjacent sides with double-sided tape. The housing is ideal for loose, unmounted prints. The print is slipped in under the polyester sheet and is held in place by the light pressure exerted by the proximity of the plastic and board. This allows the print to be handled and viewed without direct handling. The polyester and board are much larger than the housed print and a label can be placed in an upper corner to assist in identification.

The LF-Bord (lignin-free) is a sheet of 4–ply matt board that has a lignin-free sheet taped along the bottom edge with double-sided tape. This unit is useful for items that do not need to be observed directly and for items that are loose and unmounted or mounted on thin stock. The lignin-free sheet is pulled back to view the print.

Fig. 6.6 The LF-board folder is shown on the left, with the lignin-free sheet held back to allow viewing of the contents. The Mylbord-L folder is on the right. The use of Mylar for this folder allows easy viewing of the contents.

Both the Mylbord-L and the LF-Bord housings are fabricated in standard sizes and stored in horizontal print boxes, ideally in solander boxes.

Rare-book boxes as described in the Library of Congress publication *Boxes for the Protection of Rare Books: Their Design and Construction* are ideal for glass plates, as horizontal storage boxes. The various box styles can be adapted for use in a number of applications including as a solander box replacement.

Prefabricated Units

The number of items in this group is quite large, due in part to the large number of manufacturers and distributors. In an effort to limit the amount of duplication only the best-quality items will be described.

The quality of the component parts is the primary criterion used in the determination of which products to list. The appropriateness of the construction and design of the unit is then taken into consideration. The cost or relative investment is not being used in this ranking because the lower-priced units usually fail to meet these two criteria. In general, you get what you pay for. The difference in cost between two quality boxes can often be traced to the difference in the box-wall thickness or the fact that the more expensive item has features missing in the cheaper product.

STORAGE BOXES

PRINT STORAGE Solander-style, minimal wood construction (Fig. 6.7)

This type of box is made or carried by several firms. The box has excellent structural integrity and is ideal for the physical protection of prints that have been matted prior to storage in the box.

—Prints, housed
—Large-format glass plates
—Other oversized or large items to be stored horizontally

The use of solander boxes with all-wood construction should be replaced by this product. This box contains wooden components on the sides and spine only.

The top and bottom components
are a thick binder's board.

Suppliers: 1. Light Impressions Corp.
 Museum Cases
 2. Opus Binding Ltd.
 Solander Boxes

Clamshell-style, paperboard construction (Fig. 6.8)

This box is readily available from both manufacturers and binders. The structural integrity does not match that of the solander box, and care must be taken to minimize wear and tear on the box. The chemical integrity is greater than that of the solander box because the quality of the binder's board, adhesives, book cloth, and lining materials can be specified as high-quality, low in sulfur and nonreactive photographically.
The storage of matted prints is the prime application for this box.

—Prints, housed
—Large-format glass plates
—Other oversized or large items to be stored horizontally

Suppliers: 1. Conservation Resources International Inc.
 Rare Book Boxes
 2. Light Impressions Corp.
 Lipped Clamshell Boxes

Fig. 6.7 This solander box is constructed of binders board with boxwood sides.

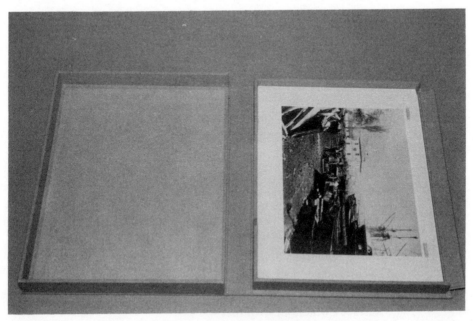

Fig. 6.8 This clamshell is constructed from binders board and should be made from paper and paperboard products which will not interact with photographic prints.

Drop Front-style, paperboard construction, metal
reinforced corners (Fig. 6.9)

This is the most common style of box and it is available in several different sizes and formats. The physical integrity is good and the chemical integrity is excellent. The many products in this group have been limited to those of three manufacturers.
The features of all boxes in this group include: acid-free, lignin-free, quality fiber with high alpha-cellulose, alum-rosin-free, low in sulfur, and, depending on the application, with or without buffering.

—Prints, loose
—Prints, housed
—Large-format glass plates
—Large-format plastic supports
—Other large items to be stored horizontally

Suppliers: 1. Conservation Resources International Inc.
as Drop Front Boxes, Lig-free Type I or Type II
2. Light Impressions Corp.
as True*Core Drop Front Boxes
3. University Products Inc.
as Perma/Dur Drop Front Boxes

Side Drop-style, corrugated paperboard construction,
no metal reinforced corners (Fig. 6.9)

This box style has excellent strength and can be shipped and stored collapsed flat. The disadvantages include the large holes in the bottom and top surfaces which allow direct access to the interior and the fact that the drop is on the side or

—Prints, loose
—Prints, housed

Fig. 6.9 These two boxes are economical alternatives to the two previous boxes. The corrugated box on the left has a drop side. The boxes are shipped and stored flat and are assembled as required. The box on the right has metal-reinforced corners.

Fig. 6.10 This collection of boxes includes the clamshell glass plate box in the foreground, the side flip box for intermediate format plastic supports at left, and in the upper right the slide storage box made from a quality paperboard.

Fig. 6.11 The boxes for microfilm (left), and for microfiche (right) are made from quality paperboard, in particular Lig-free Type 11 stock produced by CRI.

short side rather than the front or long side. This last feature results in greater difficulty in returning materials to the box without catching the corners.

Suppliers: 1. Conservation Resources International
 Corrugated Print Storage Boxes in
 Lig-free Type I or Type II
 2. Process Materials Corp.
 as Archivart Print and Photo Storage Boxes

SLIDE STORAGE Cabinet-style, metal (baked enamel) construction

The use of metal cabinets for physical protection and baked enamel for chemical inertness is the ideal combination for contemporary 35mm color slide (transparency) storage. These cabinets can also be purchased in the lantern-slide format. This particular storage format allows easy access ideal for an active, accessed collection.

—35mm color slides (transparencies)
—Lantern slides (Neumade only)

Suppliers: 1. Light Impressions Corp.
 Luxor products
 2. Light Impressions Corp.
 Neumade products

Box-style, plastic (polypropylene) construction

The use of this plastic box is ideal for the contemporary collection stored in plastic pages, particularly slides (transparencies). This is an

—Color slides (transparencies)
—Materials stored in plastic pages and sleeves

easily accessed storage form with better security than the metal cabinets.

The plastic box can be used to house other materials stored in standard-sized plastic pages such as Print File or Saf-T-Stor.

—Small-format materials to be stored horizontally

Suppliers: 1. Light Impressions Corp.
Polypropylene Box

Box-style, paperboard construction (Fig. 6.10)

This box is constructed from high-quality paper, ideal for use with photographic materials. The internal division is 20 holders of 20 each, a total of 400 slides in a high-density storage unit which should not be accessed regularly.

—35mm color slides (transparencies)

Suppliers: Conservation Resources International
Slide Storage Box in Lig-free Type II

GLASS AND PLASTIC STORAGE

Clamshell-style, paperboard construction (see Print Storage) (Fig. 6.10)

This style of box is ideal for the storage of glass plates and plastic supported artifacts. The degree of protection these boxes provide is appropriate for brittle glass plates, stored horizontally. Plastic-based artifacts can be stored vertically if space is a constraint.

—Glass plates
—Lantern slides
—Plastic based materials
—Small, heavy, or delicate artifacts to be stored horizontally

Suppliers: 1. Conservation Resources International
Rare Book Boxes
2. Light Impressions Corp.
Lipped Clamshell Boxes

Side Flip-style, paperboard construction (metal reinforced corners) (Fig. 6.10)

This box is best used with plastic-based supports, although glass can be stored in these units if care is taken to insure that the box doesn't tip over. Partially filled boxes are not balanced properly and tip easily when the cover is raised. Load and unload these boxes on their backs (horizontally) to eliminate this problem.

Suppliers: 1. Conservation Resources International
Photographic Negative and Glass Plate Storage Boxes in Lig-free Type I or Type II.
2. Light Impressions Corp.
Flip*Top Boxes

MICROFILM/FICHE STORAGE

Side Flip-style, paperboard construction (metal reinforced corners) (Fig. 6.11)

These boxes are similar to the glass and plastic storage boxes described above but are formatted for microfiche. The microfilm boxes are similar as well and are formatted for 35mm microfilm. Either Type I or Type II Lig-free can be used in this application, but Type II is preferred.

—35mm microfilm
—Microfiche

Suppliers: Conservation Resources International
as Microfilm Storage Box,
Microfilm Storage Case in either
Type I or Type II Lig-free

Global Housing

Global housing is used to describe the structural, load-carrying members of the general housing components. These are typically open shelving ranges or plan-file drawers or some other large storage platform. These global storage units also include contained microenvironments, such as low-temperature rooms or vaults.

Shelving

Shelving materials for use in the storage of photographic materials are constrained by the same factors as the other storage components discussed earlier in this chapter. Metal with a baked enamel finish is the most commonly recommended shelving material. Wood and particularly softwoods and hardwoods such as oak are not to be used for the storage of collection materials. Wood products must be eliminated, including particle board and masonite, both of which can release oxidizing chemicals, primarily from the raw wood but in some cases from the type of adhesive used in the lamination process.

The range of metal shelving available is extensive, and tends to be one of two forms, compact shelves or conventional ranges. The use of compact shelving tends to be limited to space-restricted areas where the added cost of this type of shelving is offset by the demand for storage area. It is also appropriate for the special microenvironments where the cost of the space is expensive and the best space utilization is required.

Conventional shelving should be able to hold large and oversized materials without stressing the shelves. The use of library-style shelving for the storage of photographic prints is inappropriate, since the size, shape, and weight considerations for print boxes differ significantly from books and bound materials stored upright.

Another consideration in purchasing shelving is to eliminate the use of canti-levered shelving configurations popular with library shelving manufacturers. The inability to slide boxes across the entire width of the shelf because of the cantilever struts reduces flexibility in organizing the collection independently of box size. The important construction detail to request is a single shelf size slightly larger

than the largest print box, or a multiple of it for smaller sizes, and the shelving to be structured on a welded box model.

Carts

The design of the carts used in the collection and particularly in storage environments is very important. The feature of greatest concern is size: the carts should fit between the storage ranges. The largest cart should be slightly larger than the largest box storage unit and print storage box housed in the collection.

The top of the cart should be used to transport the larger boxes, no more than two in height, and ideally only one, with smaller boxes being placed on the lower shelves, of which there are no more than two. The cart should have ambidextrous wheels that allow turns in any direction. The cart's tires should be large-diameter, soft, and shock-absorbing to insure that jolts and impact from elevator gaps and door frame threshholds do not jar the boxes on the cart shelves. The cart must have bumpers on the vertical cart supports, the outside supporting members, to absorb minor impact.

Vaults

The vaults represent the general storage environment, and the spaces and surfaces within them must be kept clean with regular housekeeping. The floors should not be carpeted but rather have sealed concrete or tile. The maintenance of this space should be balanced by the degree of dirt build-up due to staff traffic and dirt generated by handling of the collection materials, some of which may not yet have been properly cleaned and housed.

Dry cleaning, specifically vacuuming, is the most appropirate form of vault maintenance and should be conducted routinely on a weekly basis, or as needed. This includes the shelves and work surfaces located in the vault. Wet mopping with a damp mop is an appropriate weekly procedure, after dry cleaning, for collection vaults containing unprocessed materials which are prone to shedding or for heavy use areas. Wet washing and waxing are inappropriate for the vault spaces. Chemical cleaning agents should never be used in these spaces.

Cold and Cool Storage Vaults

Special-application vaults with microenvironments are becoming commonplace in photographic collections, particularly those with special applications such as contemporary color prints and materials, cellulose acetate, and cellulose nitrate supports.

The application of low-temperature storage is based on an established chemical principle. The rate of the deterioration of materials is altered with changes in temperature; lowering the storage temperature results in a reduced rate of deterioration. When applied to color dye print materials and to deteriorating cellulose nitrate artifacts, this procedure retards the deterioration processes up to several hundred years when the temperature is dropped to 0°C or 32°F.

The use of a depressed temperature will require special packaging of the photographs and special conditioning prior to sealing in vapor-proof bags and the opening of these bags after removal from the cold storage areas.

The use of cool, rather than cold, temperature storage to retard the deterioration rate without using a temperature low enough to require special packaging is the model recommended for collections where access is a consideration. The most important point here is to insure that the dew point is not exceeded. The dew point is the temperature at which condensation will form on a warm object placed into a cool environment or an artifact that is taken from a cold environment to a warmer one. The relative humidity is also a consideration. The microenvironments should be relatively dry to reduce the possibility of crossing the dew point. This precaution will allow active and direct access to the stored materials.

It is important that the storage vault microenvironment be coordinated to the user environment to insure that a dew point is not crossed but also to insure that the photograph does not go through a drastic moisture change. The organic components present in photographs are very sensitive to changes in the moisture content of their environment and will change to try and match the environment they are in. This change in moisture content is associated with a change in all three dimensions and could result in damage to the artifact due to introduced stresses due to expansion or contraction.

Housing Models
This section will deal with several discrete types of collection components which have a common element and will model an appropriate storage configuration for these pieces.

Cellulose Diacetate Supports
Situation: A cellulose acetate film collection (silver gelatin). This collection is composed of roll film and sheet film taken by the same photographer from the 1930s through to the late 1950s. The material is to be archived with limited use by patrons.

Organization steps —Segregate materials by size
—Identify and segregate nitrate
—Clean, sleeve, or enclose acetates
—Duplicate diacetates immediately, or
—Clean and freeze in foil bags
—Box collection by format in appropriate storage boxes

Silver Prints
Situation: A collection of loose and matted silver prints. These are study prints to be used by students during a semester.

Organization steps —Segregate loose items from matted items
—Construct Mylbord-L folders in standard sizes
—Place the matted and Mylbord-L items into appropriate size horizontal storage boxes, ideally solander boxes.

Collodion Glass Plates
Situation: A collodion glass plate collection of negatives. These are to be copied and then placed into limited use.

Organization steps —Clean and place into buffered four-flap enclosures
—Construct clamshell boxes to house the plates

Photographic Album
Situation: A photographic album, to be used by researchers.

Organization steps —Clean and secure loose photographs
—If album pages are loose, encapsulate and post-bind the album
—If the album pages cannot support the photographs due to deterioration, consider reformatting into an archival or hand-bound album
—Construct rare-book box to house album

Panorama Prints

Situation: A collection of rolled panorama prints, to be housed.

Organization steps —Flatten the prints as instructed in the stabilization section, pg. 99

—Clean and sleeve the prints in polyester or triacetate sleeves of an appropriate size

—Box in a solander or drop-front print box of an appropriate size

Cased Photographs

Situation: A collection of photographs in union cases, to be housed.

Organization steps —Segregate the images by process

—Remove and rebind all cased images that show glass deterioration, weeping as described in the stabilization section, pg. 100

—House in the case photograph housing.

Loose Albumen Prints

Situation: A number of loose albumen prints require housing.

Organization steps —Clean and house in Mylbord-L housings or inlay and matt with the window outside of the print perimeter

—Box in a solander box or a drop-front box

The probability that any given situation within your collection is completely resolved by the brief housing configurations provided is small. The purpose of this exercise is to provide models and viable approaches to the problems you might encounter in your collections. The approaches will have in common the basic pattern described in these examples:

—segregate and organize materials

—clean and stabilize these artifacts

—house the stable materials in appropriate housing configurations

—put the items requiring conservation treatment on a priority list and store those items that will not be treated

The number of different combinations and options is extensive, and the proper choice can be made and implemented only by individuals working directly with the collections. The use of a collection by patrons will require a higher level of preparation, screening, and conservation treatment for a given artifact than a total storage environment. The selection and application of the many options are yours to make.

The last remaining topic to be discussed is the relationship between the collection manager, collector, or curator and the conservator of photographic materials when conservation treatment is required.

7

Conservation Services

The relationship between the different individuals and professionals requiring conservation services and the conservator who will provide the service has been clarified in recent years. The observation and compliance of conservation practice with established and recognized Codes of Ethics are now commonplace and provide a minimum level of responsibility which both parties can use to insure that conservation treatments are both conservative and responsible.

The present Codes of Ethics for conservators are generally based on a museum application. This is to say that the use and treatment of a given photograph will be considered in the context of the photograph as a component in a museum collection. The very same artifact in an archive collection or in a library collection might receive very different treatment, one possibly considered unacceptable in the museum context.

The following example may clarify the point. The same photographic print existing in two different collections, one in a museum and the other in an archive, is prioritized for conservation treatment. The two images, possibly printed at the same time, both have extensive image fading; the image is no longer clearly visible. It may be appropriate, in the context of the archive collection, to subject the image to a chemical enhancement treatment to render the documentary information in the print for research or record purposes. The identical image, as part of a museum collection, would not be given the same treatment because it would alter irreversibly the photographic artist's work.

The concept of reversibility is the cornerstone to the conservation Codes of Ethics presently in use. Reversibility itself may not be a concept that can be applied in conservation practice to photographs (it is based primarily on painting conservation practice). Given the nature of the materials that comprise photographs, reversibility should be advanced and supported whenever possible. The

application of chemical treatment baths to photographic images cannot be supported by the existing codes.

The complexity of this situation is best exemplified by the problems associated with conservation treatments requested by individuals. The desire to present a given photograph in the best visual and physical condition has a direct relationship to the value of the photograph and its saleability. That the treatment may not comply with conservation attitudes and codes may not be important to all parties involved in the transaction.

EXPECTATIONS

The balance between expectations and viable conservation treatment should be discussed at length with the conservator who will perform the treatment. The treatment sequence should be designed primarily to stabilize and secure the artifact and, if consistent with good practice, also enhance the visual attributes of the photograph. In general, both of these aspects can be obtained.

The dialogue with the conservator must include documentation prepared by the conservator prior to treatment application, detailing the condition of the photograph, the treatment sequence proposed, and the authorization of an individual responsible for the photograph itself. This documentation should be reviewed with the conservator, ideally in person, and the treatment sequence and options available should be clearly understood by the individual authorizing the treatment. The consolidation of a working relationship between both parties may result in a less formal relationship, but rigorous documentaton and authorization must always be maintained.

The approaches I have discussed in this section are my own opinions, based on my own relationships with curators, librarians, and archivists. I believe them to be conservative and responsible, and although they do not represent the opinions of some of my colleagues, I believe they are points you should consider when selecting a conservator.

CONSERVATION TREATMENTS

Typical conservation treatments should now be discussed to help clarify terminology and explain the processes associated with a given treatment. The following are general treatment steps applied to photographs:

- *Dry cleaning* has been discussed in this text, pg. 78, and is designed to provide for the removal of dirt and undesirable surface contamination which can damage the artifact or interfere with subsequent treatment steps. Dry cleaning includes solvent applications as well as dry powders (eraser bits).

- *Wet cleaning* or washing is designed to remove soluble materials, particularly decomposition materials, from the artifact. The most common treatment involves the use of controlled quality water, but it can also include immersion treatments in solvent baths.

- *Bleaching* is not a routine treatment step and it cannot be applied to some artifacts because of their chemical or physical sensitivities. The option most commonly used is solar or ultraviolet bleaching even though the effect is not yet fully understood. Chlorinated bleaching treatments should not be used although a few applications do exist for this bleach. This treatment step should be defended by the conservator during the treatment proposal review process.

- *Adhesive tape removal*, particularly the pressure-sensitive varieties, is an important treatment step. The discoloration of these tapes results in stains which cannot be removed totally from the print's paper support. Early removal is important and the treatment will require solvent application or a solvent immersion bath.

- *Mount removal* is a very common treatment step and is in most cases a very important stabilizing treatment for the mounted photograph. The poor quality of the paper to which most historic prints have been mounted results in embrittlement of the secondary support (mount) and can lead to the tearing and physical damage of the mounted print. The removal from the mount is usually achieved using water baths of different temperatures.

- *Backing or lining treatments, fills, and tear repairs* are also common treatment steps. The adhesive is usually a water-based starch and the repair, fill, or lining papers are Japanese. Situations may arise in which the adhesive changes or the lining paper differs, but the most common materials include the above.

- *Inlays or add-ons* are limited treatments designed to provide a paper window or edge for the photograph to facilitate its presentation during matting. The most common application is for unmounted, flush-cut albumen prints.

- *Retouching or compensation* generally involves the application of water color to the repaired areas of a print. The need to add this step to the treatment sequence should be questioned, and if treatment is to proceed the application areas should be detailed.

- *Chemical image enhancement* should not be utilized as a treatment step. The decision to apply a chemical enhancement step, if recommended, should be reviewed by a minimum of two other conservators. If the treatment is utilized, an attempt must be made to identify this fact on the artifact. The conservation documentation must be maintained with the photograph.

CHOOSING A CONSERVATOR

The choice of a conservator should now be an easier operation for anyone seeking conservation work. There are professional organizations in the United States, Canada, and many other countries that can assist you in finding a conservator. The American Institute for Conservation, AIC National Office, 3545 Williamsburg Lane, NW, Washington, DC, 20008 is a conservation information source. In Canada the professional organization to contact is the International Institute for Conservation—Canadian Group, IIC-C6, PO Box 9195, Ottawa, Ontario, K1G 3T9.

The organizations listed above will help you locate a conservator, but remember: you need to feel that the person you are dealing with is looking after the best interests of the photographs to be treated.

If it isn't damaged, preserve it.
If it is damaged, conserve it.

Suppliers

Supplier	Product category	Product
Abbeon Cal. Inc. 123 Gray Avenue Santa Barbara, California 93101 (805) 966–0810	Equipment, Tools,	assorted assorted
Aiko's Art Materials Import 714 North Wabash Avenue Chicago, Illinois 60611 (312) 943–0745	Paper,	Japanese handmade
Andrews, Nelson, Whitehead 31–10 48th Avenue Long Island City, New York 11101 (718) 937–7100 Aimee Kligman, Fine Papers Division	Mattboard, Paper,	assorted Western handmade Japanese handmade
Conservation Materials Ltd. P.O. Box 2884 Sparks, Nevada 89431 (702) 331–0582 Doug Adams, President	Equipment, Supplies, Tools,	assorted assorted assorted

Conservation Resources International 8000-H Forbes Place Springfield, Virginia 22151 (705) 321–7730 Bill Hollinger, President	Boxes, Paper, Plastic,	assorted assorted polyester and polypropylene
Franklin Distributors Corporation P.O. Box 320 Denville, New Jersey 07834 (201) 267–2710	Sleeves,	polypropylene slide pages
Jensen Bindery 8403 Cross Park Dr. Suite 2E Austin, Texas 78754 (512) 837–0479 Craig Jensen, Proprietor	Housings, Albums,	custom photographic
Kleer-Vu Industries Ltd. Brownsville, Tennessee 38012 (901) 772–5664	Sleeves,	polypropylene
Light Impressions Corporation P.O. Box 3012 Rochester, New York 14614 (716) 271–8960 Denis Inch, Vice President	Boxes, Paper, Plastic, Supplies,	assorted assorted polyester, acetate and polypropylene assorted
Opus Binding 15 Capella Court Unit 105 Nepean, Ontario L2X 7X1 CANADA (613) 727–5063 Perry Coodin, Proprietor	Boxes,	solander
Photofile 2000 Lewis Avenue Zion, Illinois 60090 (312) 872–7557	Sleeves,	polyethylene

Process Materials Corporation 301 Veterans Boulevard Rutherford, New Jersey 07070 (201) 935–2900 Bob Stiff, Sales Manager	Boxes, Paper,	assorted assorted
Science Associates P.O. Box 230 Princeton, New Jersey 08540 (609) 942–4470	Equipment,	VU meters
Spectronics Corporation P.O. Box 483 Westbury, New York 11590 (516) 333–4840	Lamps,	Ultraviolet
TALAS 213 West 35 Street New York, New York 10001 (212) 736–7744 Elaine Haas, President	Supplies, Tools,	assorted assorted
Taylor Made P.O. Box 406 Lima, Pennsylvania 19037 (215) 566–7067 Tuck Taylor, President	Sleeves,	polyester
Weathertronics P.O. Box 41039 Sacramento, California 95841 (916) 481–7750	Equipment,	hygrothermographs

Bibliography

Key articles and books are preceded by an asterisk.

Adelstein, Peter Z.; Graham, C. Loren; West, Floyd E., "Preservation of Motion Picture Color Films Having Permanent Value." *Journal of the SMPTE*, Vol. 79, November 1970, pp. 1011–1018.

Albright, Gary, "Photographs." *Conservation in the Library*. Susan Schwartzburg, ed., Greenwood Press, Westport Connecticut, 1983.

ANSI PH 1.28—1981 Specifications for Photographic Film for Archival Records, Silver-gelatin Type on Cellulose Ester Base.

ANSI PH 1.31—1973 Determination of Brittleness of Films.

ANSI PH 1.41—1981 Specifications for Photographic Film for Archival Records, Silver-gelatin Type on Polyester Base.

ANSI PH 1.43—1983 Photography (Film)—Storage of Processed Safety Film.

ANSI PH 1.45—1981 Practice for Storage of Processed Photographic Plates.

ANSI PH 1.48—1982 Photography (Film and Slides) Black-and-White Photographic Paper Prints—Practice for Storage.

ANSI PH 1.53—1984 Photography (Processing) Processed Films, Plates and Paper—Filing Enclosures and Containers for Storage.

ANSI PH 4.32—1980 Method for Evaluating the Processing of Black-and-White Photographic Papers with Respect to the Stability of the Resultant Image.

ANSI PH 4.8 —1978 Methylene Blue Method for Measuring Thiosulfate and Silver Densitometric Method for Measuring Residual Chemicals in Films, Plates and Papers.

*Barger, M. Susan, *Bibliography of Photographic Processes in Use Before 1880: Their Materials, Processing and Conservation*. The Graphic Arts Research Center, Rochester Institute of Technology, Rochester N.Y., 1980.

Barger, M. Susan, "Daguerreotype Care." *Picturescope*, Vol. 31, No. 1 Spring 1983, pp. 15–16.

Brill, Thomas B., *Light, Its Interaction with Art and Antiquities*. Plenum Press, New York, 1980.

*Brown, Margaret R., *Boxes for the Protection of Books—their Design and Construction*, Library of Congress, Washington D.C., 1983.

Burgi, Sergio, "Fading of Dyes Used for Tinting Unsensitized Albumen Paper," presented at the SPSE International Symposium on the Stability and Preservation of Photographic Images, Ottawa, 1982.

Calhoun, J.M., "Storage of Nitrate Amateur Still Camera Film Negatives." *Journal of the Biological Photograph Assoc.*, Vol. 21, No. 3, August, 1953, pp. 1–13.

*Cartier-Bresson, Anne, *Les Papier Sales—alteration et restauration des premieres photographies sur papier*, Direction des Affaires Culturelles de la Ville de Paris, Paris, 1984.

*Clapp, Anne F., *Curatorial Care of Works of Art on Paper*, Nick Lyons Books, New York, 1987.

Coe, Brian, Haworth-Booth, Mark, *A Guide to Early Photographic Processes*, Victoria and Albert Museum, 1983.

*Collings, T.J., Young, F.T., "Improvements in Some Tests and Techniques in Photograph Conservation." *Studies in Conservation*, 1976, Vol. 21, pp. 79–84.

*Crawford, William, *The Keepers of Light*, Morgan & Morgan Inc., Dobbs Ferry, New York: 1979.

Eastman Kodak Co., *Conservation of Photographs*. Kodak Publication No. F-40, Rochester, New York.

*Eastman Kodak Co., "AE-22 Prevention and Removal of Fungus on Prints and Films." Dept. 454, 343, State Street, Rochester, NY 14650.

Eaton, George T., "Preservation, Deterioration, Restoration of Photographic Images." *Deterioration and Preservation of Library Materials*. Howard W. Winger and Richard Daniel Smith, eds. University of Chicago Press, Chicago, 1970.

Eaton, George T., *Photographic Chemistry in Black and White and Color Photography*, 2nd edition. Morgan & Morgan Inc., New York: 1965.

*Eder, Josef Maria, *History of Photography*, Translated by Edward Epstean, Columbia University Press, New York, 1945, Dover Press reprint, New York, 1978.

Enyeart, J.L., "Cleaning Glass Plate Negatives," *Exposure*, Vol. 12, No. 2, pp. 6–7.

Eskind, Andrew H., Barsel, Deborah, "International Museum of Photography at George Eastman House Conventions for Cataloging Photographs." *Image*, Vol. 21, No. 4, December 1978, pp. 1–31.

*Feldman, Larry; "Discoloration of Black-and-White Photographic Prints," *Journal of Applied Photographic Engineering*, Vol. 7, No. 1, 1981, pp. 1–9.

*Fordyce, Charles R., "Motion Picture Film Support: 1889–1976, an Historical Review." *Journal of the SMPTE*, 1976, Vol. 85, pp. 493–495.

Gernsheim, Helmut and Alison, *The History of Photography*, 2nd edition, McGraw Hill, New York, 1964.

Gernsheim, Helmut, *The Origins of Photography*, Thames and Hudson, New York, 1982.

*Gill, Arthur T. *Photographic Processes, A Glossary and Chart for Recognition*, Museum Association Information Sheet, 87 Charlotte Street, London WIP 2BX, No. 21, 1978.

Haddon, A.; Grundy, F.B., "On the Amounts of Silver and Hypo Left in Albumenized Paper at Different Stages of Washing," *British Journal of Photography*, Vol. 40, 1893, pp. 511–512.

*Haist, Grant, *Modern Photographic Processing*, John Wiley and Sons, New York, 1979.

Hendriks, Klaus B.; Hopkins, Diane, *Conservation of Photographic Materials: A Basic Reading List*, Picture Conservation, Public Archives of Canada, Ottawa, March, 1982.

*Hendriks, Klaus; Lesser, Brian, "Disaster Preparedness and Recovery: Photographic Materials." *American Archivist*, Vol. 46, No. 1, 1983, pp. 52–68.

The Theory of the Photographic Process, Fourth Edition, Edited by T.H. James, Macmillan Publishing Co., New York, 1977, first and second editions edited by C.E. Kenneth Mees.

*Jenkins, Reese, *Images and Enterprise*. Johns Hopkins University, Garden City, New York, 1975.

Karr, Lawrence F., ed., Conference on the Cold Storage of Motion Picture Films. American Film Institute and Library of Congress, Washington, D.C., April 21–23, 1980, *Proceedings*, August, 1980.

Katcher, Phillip, "How to Date an Image from Its Mat." *RSA Journal*, Vol. 44, No. 8, 26, August, 1978.

Keefe, Laurence E. Jr.; Inch, Dennis, *The Life of a Photograph: Archival Processing, Matting, Framing, and Storage*, Focal Press, Boston MA, 1983.

*Kolf, Gunter, "Modern Photographic papers," *British Journal of Photography*, Vol. 127, 1980, pp. 316–319.

*Lafontaine, R.H., *Recommended Environmental Monitors for Museums, Archives and Art Galleries*, Canadian Conservation Institute, Technical Bulletin No. 3, Ottawa 1970.

*Lafontaine, R.H., *Environmental Norms for Canadian Museums, Art Galleries and Archives*, Canadian Conservation Institute, Technical Bulletin No. 5, Ottawa, 1981.

*Lafontaine, R.H.; Wood, Patricia, *Fluorescent Lamps*, Canadian Conservation Institute, Technical Bulletin No. 7, Ottawa, 1982.

*Lee, W.E.; Wood, B.; Drago, F.J., "Toner Treatments for Photographic Images to Enhance Image Stability," *Imaging Technology*, Vol. 10, No. 3, 1984, pp. 119–126.

*MacLeod, K.J., *Relative Humidity: Its Importance, Measurement and Control in Museums*, Canadian Conservation Institute, Technical Bulletin No. 1, 1978.

*McLeod, K.J., *Museum Lighting*, Canadian Conservation Institute, Technical Bulletin No. 2, Ottawa, 1978.

McCabe, Constance, "Daguerreotype Binding," R.I.T. Photographic Preservation Workshop Handouts, 1986.

Neblette, Carroll Bernard, *Neblette's Handbook of Photography and Reprography*, Seventh Edition, Edited by John M. Sturge, Van Nostrand Co., New York, 1977.

Newhall, Beaumont, *The History of Photography*, 5th edition, New York Graphic Society, Boston, 1982.

*Norris, Debbie Hess, "The Proper Storage and Display of a Photographic Collection," *Picturescope*, Vol. 31, No. 1, 1983, pp. 4–10.

Ostroff, Eugene, "Conserving and Restoring Photographic Collections," Four Parts. *Museum News*. May–Dec., 1974.

Porter, Mary Kay, "Filing Enclosures for Black and White Negatives," *Picturescope*, Fall, 1981, p. 108.

*Reilly, James, "Albumen Prints: A Summary of New Research About Their Preservation." *Picturescope*, Vol. 30, No. 1, Spring, 1982, pp. 34–37.

*Reilly, James. *The Albumen and Salted Paper Book: The History and Practice of Photographic Printing 1845–1895*, Light Impressions Corp., Rochester NY, 1980.

*Reilly, James, *Care and Identification of 19th Century Photographic Prints*, Eastman Kodak Company, G–2S, 1986.

Reilly, James, "The Manufacture and Use of Albumen Paper," *Journal of Photographic Science*, Vol. 26, 1978, pp. 156–161.

*Reilly, James, "Role of the Maillard or Protein Sugar Reaction in Highlight Yellowing of Albumen Photographic Prints," *AIC Preprints*, 1982, pp. 160–168.

*Reilly, J.; Kennedy, D.; Black, D.; Van Dam, T., "Image Structure and Deterioration in Albumen Prints," *Photographic Science and Engineering*, Vol. 28, No. 4. 1984, pp. 166–171.

Reilly, J.; Severson, D.; McCabe, C., "Image Deterioration in Albumen Prints," Preprints 9th. International Congress of IIC, *Science and Technology in the Service of Conservation*, London, 1982, pp. 61–65.

Rempel, Siegfried, *The Care of Black and White Photographic Collections: Identification of Processes*, Canadian Conservation Institute, Technical Bulletin No. 6, Nov. 1979.

*Rempel, Siegfried, *The Care of Black and White Photographic Collections: Cleaning and Stabilizing*, Canadian Conservation Institute, Technical Bulletin No. 9, Dec. 1980.

*Rempel, Siegfried, *Enclosures for Housing Photographic Negatives*, Texas Memorial Museum Conservation Notes, No. 3, January 1983.

*Rempel, Siegfried, *Efficient Storage of Loose Photographic Prints*, Texas Memorial Museum Conservation Notes, No. 10, 1984.

*Rempel, Terry, *The Inlay: An Alternative to Backing*, Texas Memorial Museum Conservation Notes, No. 2, 1982.

Rhoads, James B., "The Applicability of UNISIST Guidelines and ISO International Standards to Archives Administration and Records Management: A RAMP Study," UNESCO, Paris, 1982.

*Sargent, Ralph N., *Preserving the Moving Image*, Corporation for Public Broadcasting, National Endowment for the Arts, Washington D.C., 1974.

Schwalberg, Bob, "Color Preservation Update." *Popular Photography*, Vol. 89, No. 1, January, 1982, pp. 81–85, 131.

*Smith, Merrily, *Matting and Hinging Works of Art on Paper*, Library of Congress Preservation Office, Washington D.C, 1981.

*Swan, Alice, "Conservation of Photographic Print Collections," *Library Trends*, Vol. 30, No. 2, 1981, pp. 267–296.

Swan, Alice; Fiori, C.E.; Heinrich, K.F.J., "Daguereotypes: A study of the Plates and the Process," *Scanning Electron Microscope*, Vol. 1 1979, pp. 411–424.

Swan, Alice, "Conservation Treatments for Photographs. A Review of Some of the Problems, Literature, and Practices." *Image*, George Eastman House, Vol. 21, No. 2, 1978, p. 24.

*Swan, Alice, "Problems in the Conservation of Silver Gelatin Prints," *Conservation of Library and Archive Materials and the Graphic Arts*, Butterworths, London, 1987.

Taft, Robert, *Photography and the American Scene*, Dover Publications, Inc., New York, 1964.

*Thomson, Garry, *The Museum Environment*, 2nd edition, Butterworths, Stoneham MA, 1986.

VanderBilt, Paul, *Filing Your Photographs: Some Basic Procedures*, American Assoc. for State and Local History, Technical Leaflet 36, *History News*, 1966, Vol. 21, No. 6, p. 8.

Weinstein, Robert A.; Booth, Larry, *Collection, Use, and Care of Historical Photographs*, American Association for State and Local History, Nashville, 1977.

Welling, William, *Collectors Guide to Nineteenth Century Photographs*, Collier, New York, London, 1976.

*Wentzel, Fritz, *Memoirs of a Photochemist*, American Museum of Photography, Philadelphia, 1960.

*Weyde, Edith, "A Simple Test to Identify Gases Which Harm Silver Images," *Photographic Science and Engineering*, Vol. 16, No. 4, 1972, pp. 283–286.

Wilhelm, Henry, "Color Print Instability," *Modern Photography*, Vol. 43, No. 2, February, 1979, p. 92.

*Wilhelm, Henry, "Monitoring the Fading and Staining of Color Photographic Prints," *Journal of the American Institute for Conservation*, Vol. 21, No. 1, 1981, pp. 49–54.

*Wilhelm, Henry, *Procedures for Processing and Storing Black and White Photographs for Maximum Possible Permanence*, Revised edition, East Street Gallery, Grinell Iowa, 1970.

Wilhelm, Henry, "Storing Color Materials: Frost-Free Refrigerators Offer a Low-Cost Solution," *Industrial Photography*, Vol. 27, No. 10, October, 1978, pp. 32–35.

Index

Note: page numbers in *italics* refer
 to illustrations

Abney, W. de W., 11
Air quality, 49–51, 66–67, 108,
 113
Albumen processes, 5–6, 62–63,
 63, *74*, 77, *77*, 83, 135, *135*,
 161
Albums, 33, 38–39, *40*, 99–100,
 144, 160
Ambrotype (amphitype), 8, 59–60,
 100–3
American Institute for Conservation,
 165
Archer, Frederick Scott, 6
Art prints. **See specific processes**
Associated housings, 145–46
Auxiliary supports, 26–28, *27*, 97
Azo paper, 7

Blanquart-Evrard, 5
Baryta/subbing layer, 14, 64
Binder, 13, 43, 61–64. *See also*
 Emulsion

Biological conditions, 112–13,
 117–18
Bleaching, *51*
Blistering, 16, 49, *50*, 59
Blueprint process. *See* Cyanotypes
Book cradles, 29, *29*, 33
Book snakes, 29, *29*, 33
Boxes for photographic materials,
 142–43, *143*, 145–46, 149–50,
 151, 152, *153*, 154
Bromoil processes, 11, 83, 104
Bronze powder borders, 77, *77*
Brown, Margaret, 132
Brushes, *82*, 83, 86

Calotypes (talbotypes), 4–6, 69–70,
 83
Carbon processes, 10, 83, 104
Carbro processes, 11, 83, 104
Cartes-de-visite prints, 77
Carts, 28, 157–58
Cases, photograph, 38, *39*, 100–1,
 161
Cellulose acetate, 9, 158, 159

Cellulose nitrate materials, 9, 32, 51, *51*, 64–65, 67, 69, 75–76, 86–87, 110, 127, 128, 130, 142, 158

Chemical processes, 67, 69

Chromium sensitizers, 10–11

Cleaning photographic materials. *See also* Stabilizing photographs

brushes for, *82*, 83, 86

emulsion, 83–84, *84*, 93, *93*

fungus removal, 85–86

general procedure for, 78–79

glass and plastic supports, 84, *85*

metal supports, 85

paper supports, 81, *82*, 83

spot-testing, 79, *80*, 81

Codes of Ethics for conservators, 162–63

Cold and cool storage, 121, 158–59

Collodion processes, 6–8, 10–11, 55, *56*, 63–64, 72, 136, 160

Color dye processes, 72–73, 76, 158

Color transparencies, 31–32, 36–38

Conservation services, 162–65

Copy machines, 50

Crayon photographs, 146

Creases, 15–16

Cyanotypes (blueprint process), 10, *19*, 20, *20*, 57, 83, 71, 127

Cycing conditions, 49, 108

Daguerre, Louis Jacques Mande, 4

Daguerreotypes, 4, 5, 45, *47*, 59, 60, 69, 100–2

Davy, Sir Humphry, 4

Densitometers, 118–19

Deterioration of photographs, 45–77. *See also* Environments for photographic materials: Housings for photographic materials

air quality and, 66–67

baryta layer, 64

binders, 61–64

biological, 47, 53–54

chemical processes and, 46–51, 67, 69

color dye images, 72–73, 76

glass supports, 49, *50*, 59–60

induced vs. inherent, 45–46

light and, 52

metal supports, 60, *60*

nonsilver images, 70–72

paper supports, 55, 57–58

physical, 47, 52–53

plastic supports, 53, *53*, 58, 58–59

process identification and, 46

product design and, 75–77

silver images, 65–70, *68*

stability interrelationships and, 64–65

support, 55–60

toning and, 66

Develop-out print processes (DOP), 7–8

Diacetate materials, 86–87, 128

Display. *See* Exhibition

Duplicating procedures, 86

Dye transfer prints, 127

Eder, Josef Maria, 7

Embellishments, 76–77, *77*

Emulsion, 83–84, *84*, 92–94, *93*. *See also specific types*

Envelopes, 31–32, 36–37

Environments for photographic materials, 46–54, 105–24. *See also* Housings for photographic materials

 exhibition, 118–20

 general parameters for, 105–8

 monitoring, 110–19

 patron/staff use and, 122–24

 quality of photograph and, 110

 shipment and, 120

 storage products and, *109*, 109–10

Eraser powder, 81, *82*

Examining photographic materials, 12–21. *See also* Handling of photographic materials

 environment for, 122–24

 goals of, 12

 identifying image side, 43

 light for, 19–20

 methods of, 16–21

 vocabulary for, 13–16

Exhibition, 52, 118–20

Fading, 15, 66, *74*

Ferrotype. *See* Tintype

Fiber optic light source, 123

Film, 8–9. *See also specific types*

Finger cots, 25–26, *26*

Fixing bath, 57–58, 67, 69, *74*, 74–75

Flexible supports, 8–10

Four-flap enclosures, 33, 38, 138–41

Framed prints, 35, 146

Frilling, 16

Fungi, 23, 53, *54*, 61, 85–86, 112–13, *117*, 117–18

Gaslight, 7

Gelatin processes, 5–8, 33, 49, *50*, *53–54*, *54*, 59, 61–62, 77, 139

Genotype. *See* Kallitype

Glass supports, 5, 6, 8, 33, 49, *50*, 59–60, 84, *85*, 88–89, *90–92*, 92, 139, 140, 155–56

Global housing, 157–59

Gold toning, 5, 66

Goodwin, 9

Gum bichromate prints, 83, 104, *104*

Handling of photographic materials, 21–44

 cleanliness and, 23–24

 copies vs. originals, 31

 equipment for, 26–30, *27–30*

 general procedures for, 44

 gloves and finger cots for, 24–26, *26*

 housings and, 31–40, *34*, *36*, *37*, *39*, *40*, 100–1

 incorrect, 21–22

 matted photographs, 34

 negatives, 37, *37*

 oversized, 41

 procedural aids, 30–31

 turning photographs over, 41–43

 work space for, 22–23

Hedden, 8
Herschel, Sir John, 10
Housings for photographic materials,
 31–35, 120–23, 125–61
 albums, 144
 associated housings, 145–46
 boxes, 142–43, *143*, 145–46, 149
 –50, *151*, 152, *153*, 154
 cold storage, 121, 140, 159
 deterioration and, 32, 51, 67,
 109, 109–10
 envelopes, 138–41
 four-flap enclosures, 138–41
 framing, 146
 glass and plastic artifacts, 155–56
 global, 157–59
 guidelines for, 162
 handmade, 147–48
 large or oversized formats, 147
 matts, 131–32, *133–35*, 136–38
 metal, 129–30
 microfilm/fiche housings, 156–57
 models for, 159–61
 paper, 125–28, 138–41
 plastic, 128–29
 plastic sleeves, 138, 140, 142
 prefabricated, 149
 print housings, 149
 removing photographs from, 35–
 41, *36*, *39*, *40*, 100–1
 slide housings, 154
 small formats, 146–47
 storage systems, 142–44, *143*
 tissue slip sheets, *136*, 136–138
 unacceptable, 130–31
Humidity, 48, 49, 106, 110–15
Hyatt Brothers, 8

Hygrometers, 110, 111
Hygrothermographs, 111–12, *114*,
 115
Hypo. *See* Fixing bath

Inlaying, 135, *135*
Insect infestations, 23, 53–54, *54*,
 61
International Institute for Conser-
 vation—Canadian Group, 165
Iron sensitizers, 10

Kallitypes (genotype), 10, 71
Kodabromide paper, 8

Lantern slides, 95
LeGray, Gustave, 6
Light, 52, 107, 112, 115–17, *116*
Losses, 15–16

Maddox, R. L., 7
Magnifier, 17–18, *18*
Manly, Thomas, 11
Matted photographs, 33–35, *34*,
 42–43, 131–32, *133–36*,
 136–38
Mawdsley, Peter, 7
Melainotype, 8
Metal housings, 129–30
Metal supports, 8, 59, 60, 60, 85
Microfilm/fiche storage, 156–57
Microscope, stereo, 18–19, *19*, 123
Mirroring, 15, *68*
Mold, 61, 113, 117–18
Mounted prints, 33–34, 95–96

Negatives, 3, 5, 6, 31–32, 36–38, *37*

Niepce de Saint Victor, Joseph-Nicéphore, 4, 5

Niepceotypes (albumen on glass), 5

Nonsilver image processes, 10–11, 70–72

Oil prints, 83, 104

Oversized materials, 95–96, 147

Ozotype, 11

Palladium prints, 57, 83, 137

Panorama prints, 160

Paper housings, 31–32, 36–37, 125–28

Paper supports, 5, 55, 57–58, 81, *82*, 83

Photocorners, 39

Photographic processes, 3–13, 43–44, 46, 104, *104. See also specific processes*

Photo Pastels, 83, 146

Piper, C. Welborne, 11

Plastic housings, 31–32, 38, 128–29, 138, 140, 142

Plastic supports, 9–10, 32, 51, *51*, 53, *53*, *58*, 58–59, 84, 86–87, 140, 142, 155–56. *See also specific types*

Platinum processes, 57, 66, 71, 83, 135, *135*, 137

Poitevin, Alphonse Louis, 7, 10

Polaroid SX-70 print, 55, *56*

Pollution. *See* Air quality

Polyethylene teraphthalate, 9–10

Ponton, Mungo, 10

Portriga paper, 7–8

Positive images, 3

Print-out processes, 5–7

Product design, 75–77

Protective Box for Cased Objects, 102

Psychrometers, 111, *111*, 113–14, *114*

Rawlins, G. E., 11

Resin coated (RC) paper, 58

Rodents, 53–54, 61

Rust, 60

Safety film, 9–10, 75–76

Salted silver prints, 55, *56*, 83

Schulze, Heinrich, 4

Scum-X, 81

Secondary supports, 76–77

Shelving, 157

Shipment of photographic materials, 120

Silver processes, 3–10, 65–70, *68*, 160. *See also specific processes*

Sizing, 5

Slide storage, 154

Smith, Merrily, 132

Sodium thiosulfate, *74*, 74–75

Spot testing photographs, 79, *80*, 81

Stabilizing photographic materials, 86–104

albums, 99–100

brittle prints and negatives, 967–97, *97*

case photographs, 100–2, *101*

curled prints, 97–99, *98*

flaking emulsions, 94

Stabilizing photographic materials
 (*Cont.*)
 fused material, 94
 glass supports, 88–89, *90–91*,
 92, *92*
 identification and, 104, *104*
 lantern slides, 95
 lifting emulsions, 92–94, *93*
 metal and glass supports, 100–3
 plastic supports, 86–87
Starch binders, 62
Stereomicroscopes, 18–19, *19*, 123
Subbing/baryta (isolating layer), 14
Support (base), 14, 55–60, 75–77.
 See also specific types
Swan, Joseph Wilson, 10

Talbot, William Henry Fox, 4, 10
Talbotype. *See* Calotype
Tarnish, *47*, 60, 69
Tears, 15–16
Temperature, 48–49, 106–7,
 111–15

Tintypes, 8, 60, *60*, 100–2
Toning, 5, 66
Tubes, storage, *98*
Tweezers, 28–29, *28*

Vaults, 158
Velox paper, 7

Wall, E. J., 11
Warnerke, 9
Wedgwood, Thomas, 4
Weights, anchoring, 30, *30*
Willis, William, 10
Work space, preservation, 22–23

Xerox machines, 50
Xray fluorescence spectrometer
 (XRF instrument), 20, *20*

Yellowing, 15